W9-BDC-912

IMAGES
of America

SHEFFIELD VILLAGE

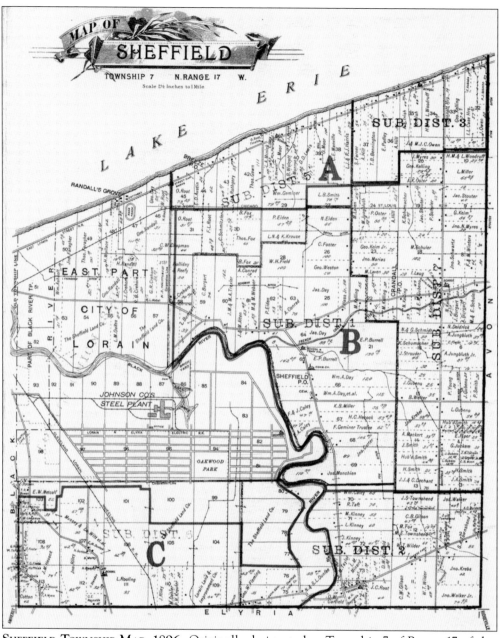

SHEFFIELD TOWNSHIP MAP, 1896. Originally designated as Township 7 of Range 17 of the Connecticut Western Reserve, Sheffield was formally established in 1824 when Lorain County, Ohio, was formed. By 1960, three Sheffields existed—the City of Sheffield Lake, the Village of Sheffield, and Sheffield Township. (Courtesy of Lorain County Metro Parks.)

ON THE COVER: SHEFFIELD LAKE VILLAGE OFFICIALS, 1930. This photograph was taken when the City of Sheffield Lake and the Village of Sheffield were still one community, the Village of Sheffield Lake. In this image are, from left to right, Deputy Marshal Henry "Harry" Garfield Root, Marshal W. L. "Roy" Clites, clerk Frank Field, Mayor Fred Hosford, and Deputy Marshals A. Welter and A. Gilles.

IMAGES
of America

SHEFFIELD VILLAGE

To Bev
Enjoy our Village
Best wishes,
Eddie Herdendorf

Charles E. Herdendorf in association with
the Sheffield Village Historical Society

ARCADIA
PUBLISHING

Published by Arcadia Publishing
Charleston, South Carolina

Printed in the United States of America

Library of Congress Control Number: 2010933058

For all general information, please contact Arcadia Publishing:
Telephone 843-853-2070
Fax 843-853-0044
E-mail sales@arcadiapublishing.com
For customer service and orders:
Toll-Free 1-888-313-2665

Visit us on the Internet at www.arcadiapublishing.com

To Ricki for her inspiration and editorial skills,
which made this book possible

Contents

ACKNOWLEDGMENTS

The author is indebted to the many members and friends of the Sheffield Village Historical Society who have contributed materials to its collections, thus making the preparation of this book possible. All illustrations presented in this book were obtained from the digital collection of the Sheffield Village Historical Society, except where noted.

Special thanks are given to the following individuals and organizations for their contributions: Abraham Nissan, Jean Blaha Ackerman, Joan Monagon Ackerman, Amherst Historical Society, Avon Historical Society, Bill and Jeannine Ferguson Barnes, Elva Garfield Behr, Brad Behrendt, Bill Bird, Black River Historical Society, Matthew Bliss, Brookside High School, Edward "Bud" Brown, Robert Bunsey, Dennis Bryden, Doris and Eleanor Burrell, Bonnie Canterbury, Glenn Carruthers, Brian and Paula Pliszka Clark, Cleveland Museum of Natural History, Pam Collins, James and Cindy Conrad, Sarah Cassell Crowl, Carl Cunningham, Chris Davis, Dennis Davis, James Day, Sandy Belu Dazell, Albert Doane, Domonkas Library, EcoSphere Associates, John Edwards, John Eiden, Marilyn Fedelchak-Harley, Dr. Del and Jean Fischer, Lloyd and Ron Forster, Fr. Bob Franco, Alice Garfield, Edward "Bud" Garfield, Edgar Day Gates, Catherine Price-Gentile, Harry Gerent, Dan Gillotti, Tom Greenwood, Ruth Kriebel Guggenbiller, David Hammer, Donnie Hammer, Ruth Root Hammer, Edward and Kathryne Root Herdendorf, Ricki Crowl Herdendorf, David and Elaine Hibbard, Bob and Mary Lou Hiltabiddle, Jack and Patsy Hoag, Thomas Hoerrle, Dorothy Cunningham Hribar, Steve Huether, John Hunter, Bill Johnson, David Ireland, Kathy Keefer, Lee Kelling, Matt Kocsis, Donald Kriebel, Roy Kudrin, Ralph Lattig, Martha and Charles Leveillee, John Little, Lorain County Historical Society, Lorain County Metro Parks, Karis Lyon, Gladys Wisnieski Mackert, Rita Martinez, Nancy and Elmer Meyers, Andy and Carol Day Minda, Col. Matt Nahorn, Frank Nesbit, Richard Novak, Oberlin Heritage Center, Douglas and Darlene Ondercin, Old Woman Creek State Nature Preserve, David Perritt, Susan Langthorp Post, Dr. Brian Redmond, Joe Richvalsky, Harry Rider, Patricia McAllister Riegelsberger, Pamela Rihel, Frank and Jessie Root, George and Belle Root, Harry and Ada Rider Root, Jack and Helen North Root, Ron Sauer, Carol and Fred Scharmann, Clayton and Jean Bungart Schneider, Dick Sevits, Leo and Barbara Wagner Sheets, Sheffield Village Firefighters, Sheffield Village Police Department, Jeff Sigsworth, Lois Shinko, Frank and Carolyn Sipkovsky, Len Smith, Lola Smith, Taylor "Jack" Smith, Thomas Smith, St. Mark Church, St. Teresa Church, Dr. Ronald Stuckey, Village of Sheffield, Debbie Wehler, Ralph White, John Whitney, Meredith Williams, Gladys Jungbluth Wisnieski, and Kathleen Yancer. Their generosity is greatly appreciated.

INTRODUCTION

Sheffield Village is rich in human history that began several thousand years ago with Native American occupation along the beach ridge of an ancient glacial lake and at the confluence of tributaries to the Black River. Archaeological evidence indicates that several Native American cultures established settlements in Sheffield over the ages, but by the mid-1600s few were left in northeastern Ohio.

Soon after the War of 1812, hearty pioneers from New England began to recognize the natural attributes of northern Ohio. In January 1815, Capt. Jabez Burrell and Capt. John Day of Sheffield, Massachusetts, purchased a large tract of land designated as Township 7 of Range 17 in the Connecticut Western Reserve. They formed a partnership with several other Massachusetts families, and later that year, and the following spring, settlers began to arrive in the valley of the Black River at the mouth of French Creek where they built log houses and founded a community they called Sheffield in honor of their former home.

Living up to a provision in the purchase agreement, in 1817 Captains Burrell and Day erected the township's first sawmills and gristmills along the Black River about 0.5 miles upstream from the mouth of French Creek. The settlers also built a schoolhouse and a Congregational church. Milton Garfield was the first to settle on North Ridge, clearing the native forest for his 100-acre farm. When Lorain County was formed in 1824, the population of Sheffield included 44 adult males and their families. The first action of the new county commissioners was to officially establish Sheffield as a township.

In 1836, Oberlin College established the Sheffield Manual Labor Institute on the Burrell Homestead in Sheffield where, for the first time in the nation, women and African American students were permitted to attend college classes alongside white male students. Another major wave of settlers came to Sheffield in the 1840s and 1850s, when immigrants from Bavaria arrived and eventually built St. Teresa of Avila Catholic Church. Prior to the Civil War, several Sheffield residents, such as Robbins Burrell and Milton Garfield, were active abolitionists and operated stations on the Underground Railroad. Capt. Aaron Root, a Great Lakes shipmaster from Sheffield, secretly carried runaway slaves aboard his vessels to freedom in Canada. During the Civil War, many of Sheffield's sons served in the Union army and navy; 23 of them are buried in the village's Garfield Cemetery on North Ridge.

Sheffield continued as primarily a farming community in the late 1800s, producing some 85,000 bushels of corn, oats, wheat, and barley and 30,500 pounds of butter, cheese, and maple sugar in 1878 alone. A dramatic change took place in 1894, when the city of Lorain annexed a large portion of the northwestern part of Sheffield Township, and the Johnson Steel Company (later the National Tube Company of U.S. Steel Corporation) built a large steel mill and housing development for thousands of new workers there, known as South Lorain, on the west side of the Black River. By 1906, several steam and electric railroads had been built through Sheffield to service the steel mill and provide commuter passenger service.

In 1920, township residents living east of the Black River voted to withdraw from Sheffield Township and form the incorporated Village of Sheffield Lake. In 1922, the new village constructed Brookside School to replace several one-room township schools that had been built in the 1870s and 1880s. The new school, located on the corner of Colorado Avenue and Harris Road, was opened in the fall of 1923 and had five classrooms and a gymnasium. Tragically, in the summer of 1924, the school was damaged by a tornado, but it was rebuilt in time for the start of fall classes. In 1929, Brookside received its charter, establishing it as a Grade A, Class B school, and it graduated its first senior class in 1930.

By the early 1930s, the new village was experiencing internal problems. Because the south end of the village had a sparse population with large farms, while the north end had a greater population living on small lots and working in nearby cities, the residents of these two segments found their interests to be incompatible. In 1933, the farmers in the south end voted almost unanimously to separate from the Village of Sheffield Lake. The north end remained as the Village of Sheffield Lake, while the south formed a new entity known as Brookside Township, which in 1934 was incorporated to form the Village of Sheffield. Clyde B. McAllister, a farmer from North Ridge, was elected as Sheffield Village's first mayor.

Because the new Village of Sheffield had no public buildings when it was formed in January 1934, Mayor McAllister convened the first meeting of the village council in his home. In December 1934, the village purchased the North Ridge District No. 2 Schoolhouse from the Sheffield Township School District for $500. This elegant Queen Anne–style red brick schoolhouse, built in 1883 adjacent to Garfield Cemetery, was no longer needed by the school board with the opening of Brookside School several years earlier. In 1935, the structure was converted to the Sheffield Village Hall and served that purpose for the next 65 years. In 1978, the Village Hall and Garfield Cemetery were placed on the National Register of Historic Places along with two other 19th-century structures on North Ridge—the Milton Garfield House (built in 1839) and the Halsey Garfield House (built in 1855). The Jabez Burrell House (built in 1820) on East River Road at French Creek is also listed on the National Register of Historic Places. The Sheffield Village Hall currently serves as the village clerk/treasurer's office and the office for Garfield Cemetery. Three archaeological sites within the village—the Burrell Fort Site, the Burrell Orchard Site, and the Eiden Prehistoric District—are likewise listed on the National Register of Historic Places.

In the 1940s and 1950s, Sheffield's North Ridge became known as the "Greenhouse Tomato Capital of America," as 24 acres of land were covered with glass. In 1957, a new fire station was built adjacent to James Day Park on a bluff overlooking French Creek. In 1999, this building was enlarged and now serves as Sheffield Village's Municipal Complex. In the 1960s, the Lorain County Metro Parks began preserving natural areas along the Black River and French Creek, which now includes a nature center and many miles of paved and earthen trails within Sheffield Village—the latest being the Steel Mill Trail, opened in May 2008, with high bridges over the Black River and French Creek. Today Sheffield is again in a period of transition, as farmlands are being diminished and the village moves toward becoming a modern residential and commercial center with some 1,600 homes and 230 businesses. Progress has come with some costs, as some Sheffield historic homes have been lost to commercial development. The Sheffield Village Historical Society was formed in 2005 to preserve the heritage of those who toiled building the village and who found joy in their accomplishments.

One

PIONEERS

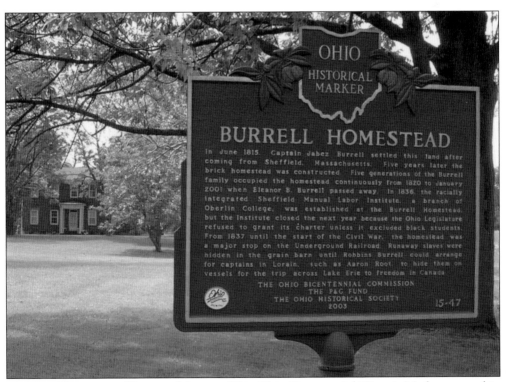

BURRELL HOMESTEAD HISTORIC MARKER. This Ohio Bicentennial Historic Marker, erected in 2003, commemorates the founding of Sheffield, Ohio, and the accomplishments of the Burrell family in the abolition movement before the Civil War and in the founding of Oberlin College. The Burrell family lived here for 185 years, until the last family member died in 2001. The property is now a museum operated by Lorain County Metro Parks.

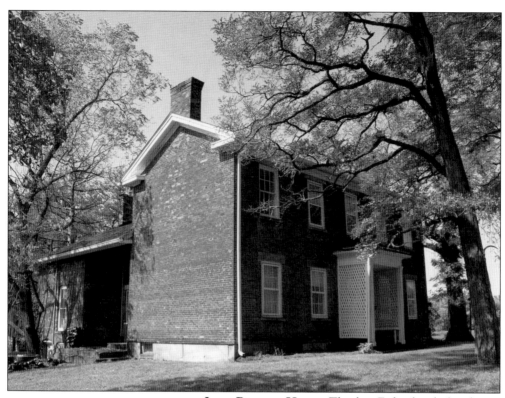

JABEZ BURRELL HOUSE. This late Federal-style farmhouse was built around 1820 by Capt. Jabez Burrell (1766–1833) on East River Road near the confluence of French Creek and Black River. Burrell and Capt. John Day of Sheffield, Berkshire County, Massachusetts, purchased the township from Gen. William Hart in 1815 and proceeded to found the settlement of Sheffield, Ohio.

ROBBINS BURRELL (1799–1877). Robbins, son of Jabez and Mary (Robbins) Burrell, operated the family farm after the death of his father. He was an abolitionist who conducted an Underground Railroad station at the homestead and secured passage across Lake Erie to Canada for runaway slaves. He was also a professor of agriculture at the Sheffield Manual Labor Institute, a branch of Oberlin College, which he established at the homestead.

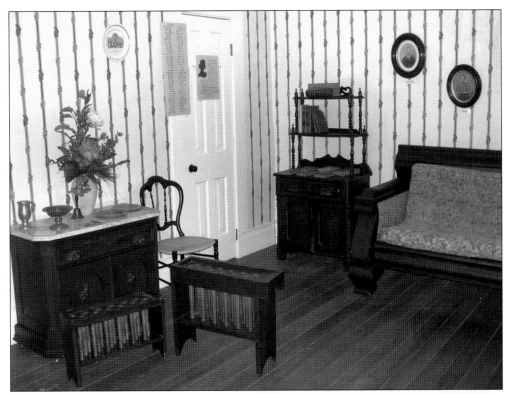

BURRELL HOUSE, NORTH PARLOR.
This elegant room was not only the main parlor at the north front of the house, but it served as the classroom for Oberlin College's Sheffield Manual Labor Institute in the late 1830s. The two pieces of furniture (lower left) with vertical tubes are actually commercial candle molds once used by the Burrell family to supplement farm income.

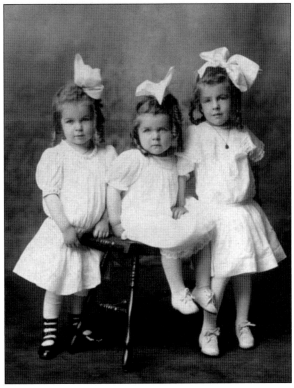

BURRELL SISTERS, 1907. This charming photograph shows the young Burrell sisters—from left to right, Virginia (1904–1976), Eleanor (1905–2001), and Doris (1903–1997). They were the daughters of Harry C. Burrell (1867–1937) and Tempe (Garfield) Burrell (1870–1949) and were the last of the Burrell family to live in the homestead. In the 1970s, the sisters negotiated a life estate arrangement with Lorain County Metro Parks to maintain the property as a museum.

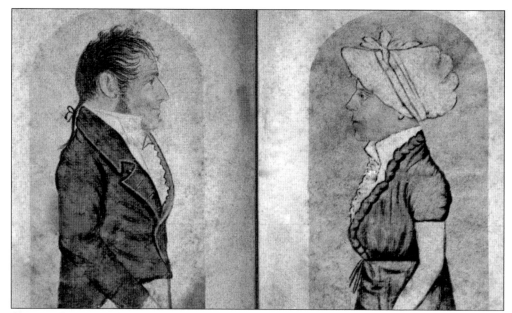

CAPTAIN JOHN AND LYDIA DAY. This sketch of Capt. John Day (1774–1827) and Lydia (Austin) Day (1775–1854) was drawn in 1809, seven years before they came to Sheffield. Captain Day received his rank for service in the War of 1812. He and Jabez Burrell were the original proprietors to settle in Sheffield. The Days arrived by wagon in July 1816, while their household goods and farming equipment came by lake schooner in August.

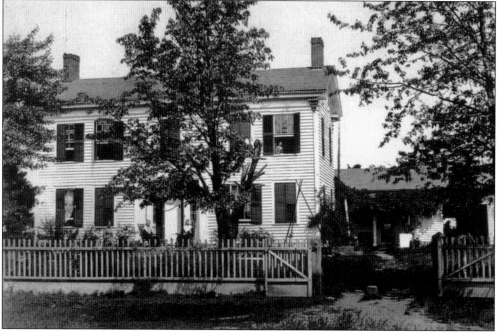

MILTON GARFIELD HOUSE, JULY 1884. This classic Greek Revival–style farmhouse, at 4921 Detroit Road, was built for the Garfield family by Ezra Jackson in 1839. Milton Garfield was the original settler of Sheffield's North Ridge in 1815. This ridge is the remnant sand beach of glacial Lake Warren that occupied the area 12,000 years ago.

MILTON AND TEMPE GARFIELD. At the age of 23, Milton Garfield (1792–1862) purchased a 100-acre plot of land on North Ridge and walked from his native Tyringham, Massachusetts, with little more than an axe and his gun. He married Tempe Williams (1800–1894) of neighboring Avon in 1820, and they started their family in a log house on the property.

MILTON GARFIELD HOUSE, 2005. Garfield homestead restoration, initiated in the 1930s and complete in 2005, resulted in a Lorain County Historical Landmark Award and placement on the National Register of Historic Places. Outstanding features include an elaborate main entrance with recessed half-columns, built-in parlor cabinets of native cherry, and a grand fireplace that is one of the few in the Western Reserve in which the warming and bake ovens are found intact.

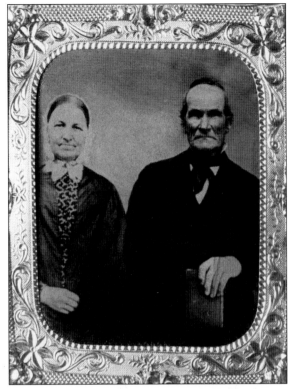

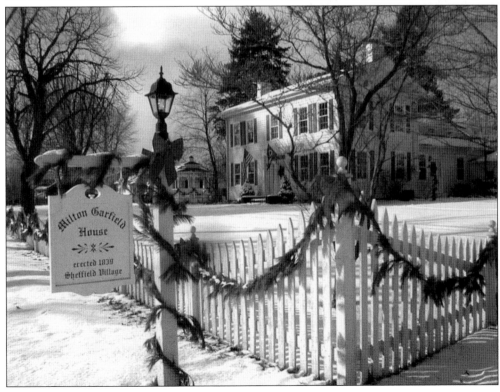

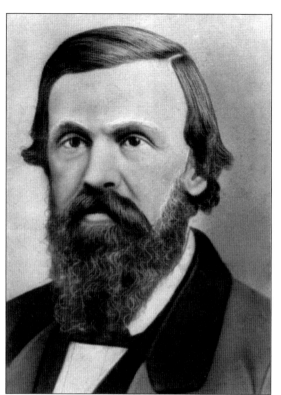

HENRY GARFIELD (1821–1892). The eldest son of Milton Garfield, Henry was an accomplished carpenter and a schoolteacher in nearby Avon. With the 1848 announcement of gold discoveries in California, he made plans with 10 men from northern Ohio to make the six-month overland trek. They called themselves the "Buckeye Company." Henry documented his journey and 20-year stay in California in a series of letters to his father and brother Halsey.

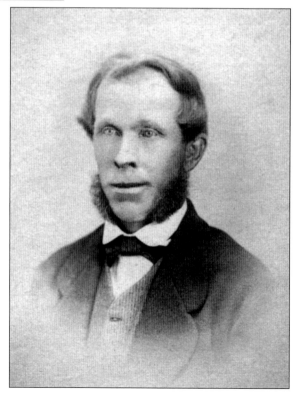

HALSEY GARFIELD (1823–1906). Halsey, second son of Milton Garfield, received a liberal education in Sheffield Township schools and in his early years taught in county schools. In the 1840s, he operated a mercantile establishment at French Creek in Avon Township with his uncle, Henry Harrison Williams. He married Harriet Root in 1855, daughter of William H. Root. In 1863, he returned to farming at the family homestead on North Ridge.

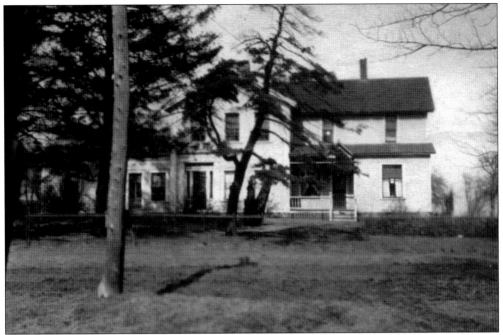

HALSEY GARFIELD HOUSE, 1880s. When Halsey and Harriet Root were married in 1855 they contracted with Douglas Smith to build their home. This fine Greek Revival–style house built on the Garfield family's North Ridge homestead is the result of this commission. In the entranceway and windows, Smith added elements of Italianate style, which was just coming into vogue at that time.

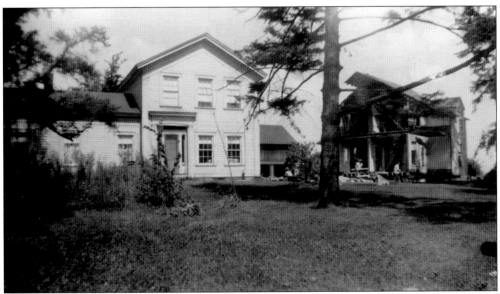

HALSEY GARFIELD HOUSE SPLIT. In the late 1930s, this house was purchased by Michael and Hazel Rath. The old farmhouse proved too large for their needs, and in the early 1940s they decided to split the house into two dwellings. This photograph shows the east wing being severed and moved about 100 feet to the east. The east wing is now known as the Lloyd House.

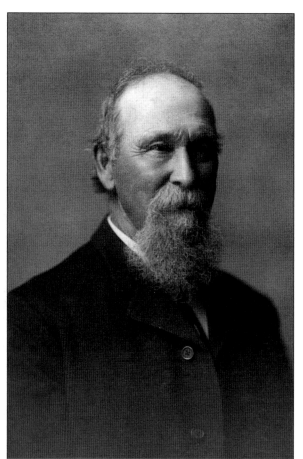

DANIEL GARFIELD (1833–1911).
The youngest son of North Ridge pioneer Milton Garfield, Daniel inherited the land just east of his father's home. He was the most prosperous farmer in the family and acquired several properties on North Ridge. He married Mary Taft in 1858, and they had one daughter, Estella. During the Civil War, Mary's brother Isaac and Daniel's brother-in-law George Smith served aboard Union navy monitor warships in the battle of Mobile Bay.

DANIEL GARFIELD BARN. This bank-style barn was built by Daniel Garfield in the 1860s on the family homestead east of the Milton Garfield House. In 2005, the property was purchased for an automobile dealership, and the barn was scheduled to be torn down. Fortunately, area historical societies were able to secure the donation of the barn, and Avon farmer Ron Krystowski agreed to disassemble the structure and rebuild it on his property.

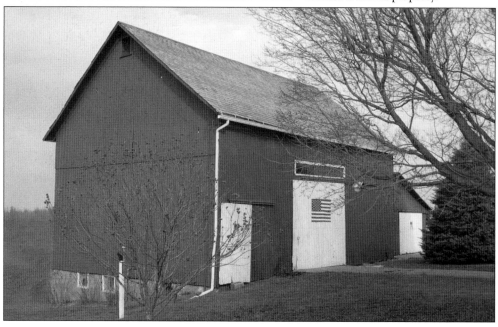

JOSHUA SMITH GRAVESTONE. As a lad of 17, Douglas Smith journeyed to Sheffield with his father, War of 1812 hero Capt. Joshua Smith (1771–1817), from Massachusetts. In November 1815, they built a rude cabin, becoming Sheffield's first permanent settlers. In September 1817, Joshua was the first Sheffield pioneer to die (gravestone pictured here in Garfield Cemetery), leaving Douglas to take care of his mother and siblings who had joined him and his father in March 1817.

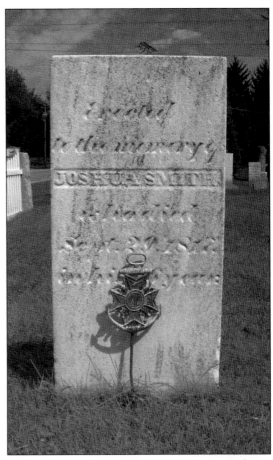

DOUGLAS SMITH HOUSE. Son of Joshua Smith, Douglas (1799–1862) in 1824 married Sarah Burrell, the daughter of Capt. Jabez Burrell. Douglas became an accomplished farmer and carpenter, building several houses in Sheffield. His own home, this 1833 Greek Revival–style farmhouse below, is the oldest building on North Ridge. The house's most distinguishing feature is the heavy entablature over the main section with its excellent proportions.

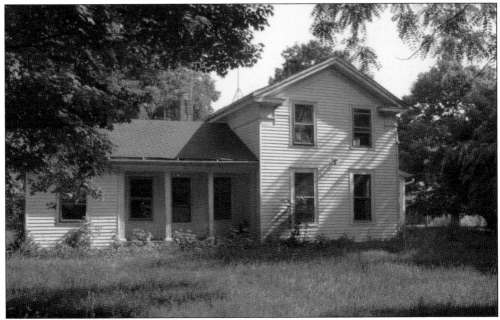

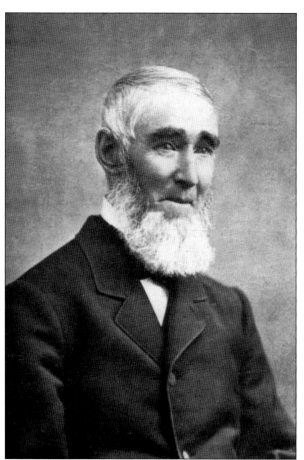

JAMES DAY (1807–1896). James was the fourth son of Capt. John Day, one of Sheffield's founders. In 1835, James married Ann Eliza Austin (1816–1873); both had come as children with their parents from Sheffield, Massachusetts. They farmed a large homestead southeast of the intersection of Colorado Avenue and East River Road and were known for having the most congenial social gatherings in Sheffield.

JAMES DAY HOUSE, 1976. This 1850s Greek Revival–style farmhouse mysteriously burned in 1986. It stood at 4530 Colorado Avenue, the present location of the French Creek Nature Center. After the death of James Day in 1896, his heirs arranged for Andrew Conrad to manage the homestead. In 1931, James Day's daughters— Celia, May, and Caroline—sold 43 acres to Sheffield for a park to be named in their father's honor.

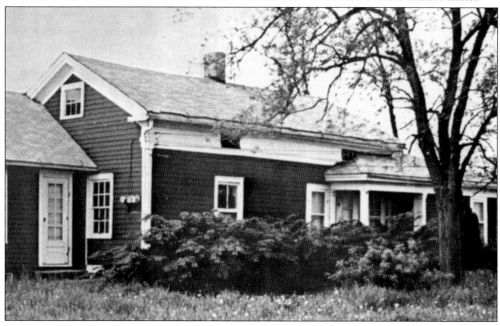

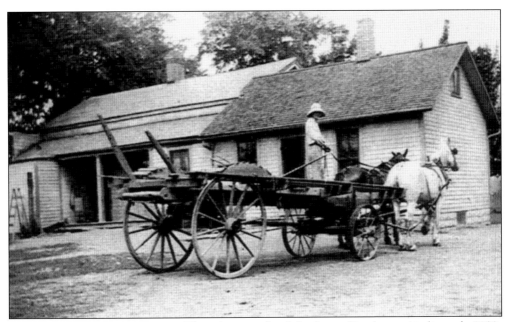

JAMES DAY HOUSE, REAR VIEW. This photograph of the James Day house in the early 1900s was taken when the Andrew Conrad family managed the James Day farm. Here Andrew's wife, Emma (Zirgman) Conrad, drives a team of horses pulling an empty hay wagon. For many years, the Conrad family lived in this house where they brought up their family.

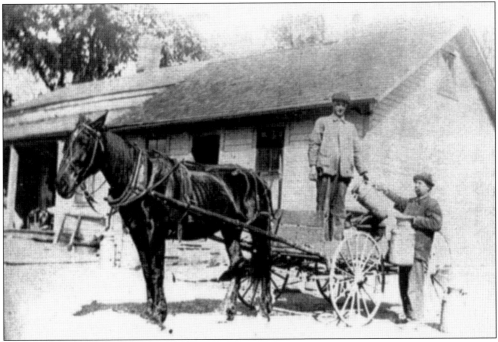

MILK WAGON AT JAMES DAY HOUSE. This photograph shows milk being picked up at the rear of the James Day house in the early 1900s. Andrew Conrad is shown here handing milk cans to the hauler. The pasture for the dairy cows was in the French Creek valley, not far from where the French Creek Nature Center of Lorain County Metro Parks is presently located.

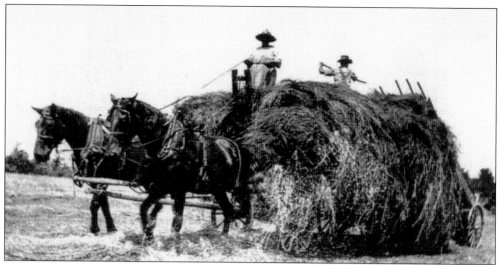

HAY WAGON ON JAMES DAY FARM. Members of the Conrad family are shown here harvesting hay as a team of horses pulls the hay wagon and the attached hay loader. The loader was put in motion by the turning of its wheels as it was drawn along behind the wagon.

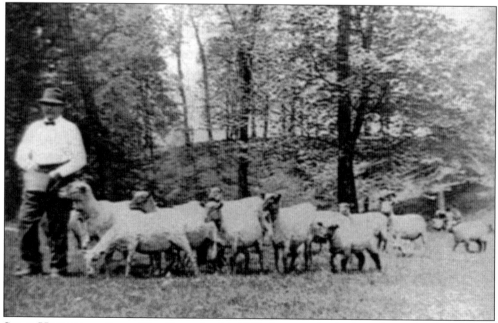

SHEEP HERDING ON JAMES DAY FARM. In this 1916 photograph, Andrew Conrad is shepherding a flock of sheep in the valley of French Creek. The Conrad family was also responsible for spring sheep shearing. The low hill in the background is still recognizable as the picnic area in Sheffield Village's James Day Park.

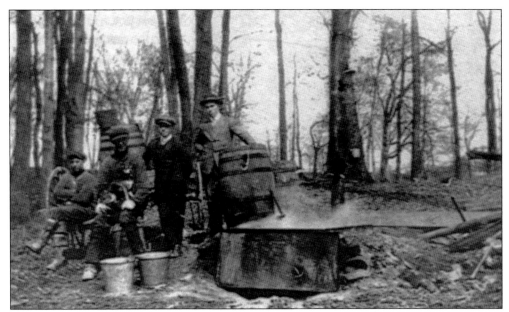

MAKING MAPLE SYRUP AT JAMES DAY FARM. This 1916 photograph shows members of the Conrad family collecting sap and stirring the evaporating pan during the syrup-making process. The French Creek valley had a sizable grove of sugar and silver maple trees that could be tapped. Interestingly, the pioneers reported that many of the maples trees showed evidence that they had been tapped by Native Americans.

WILLIAM DAY HOUSE, 1906. William Augustus Day (1835–1910), grandson of Sheffield founder Capt. John Day, built this classic Italianate-style farmhouse on East River Road in 1879. The house was planned by an architect and has formality and dignity not usually found in farmhouses. The home sits far back from the road on a tree-shrouded ridge overlooking a small tributary to French Creek.

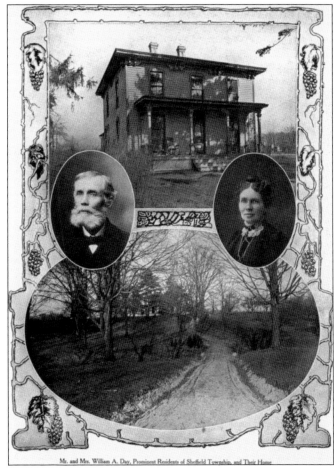

Mr. and Mrs. William A. Day, Prominent Residents of Sheffield Township, and Their Home

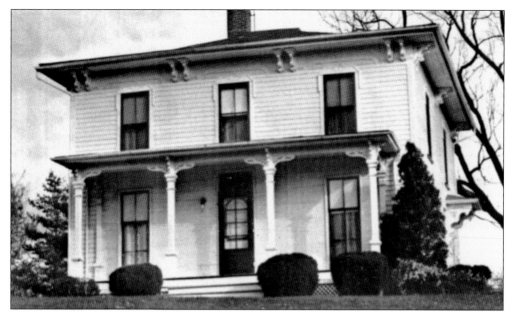

WILLIAM DAY HOUSE, 1976. William Augustus Day married Mary Steele of Oberlin, Ohio, in 1861. The couple had two children—Maude Day (1862–1948) and William Steele Day (1863–1941). William Steele married Maggie Pigg of London, Kentucky, in 1898. Their eldest son, Sumner William Day (1899–1983), lived in the house until his death. His daughter Carol (Day) Minda and her husband, Andrew, now make their home here.

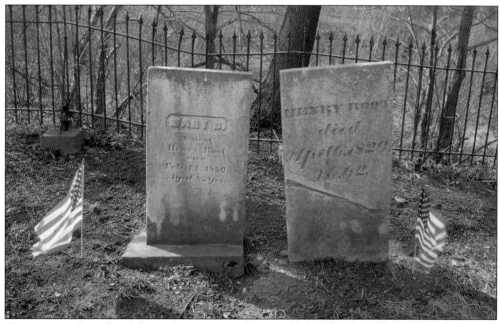

HENRY AND MARY (DAY) ROOT. Henry (1767–1829) and Mary (1772–1859), along with their six children, arrived in Sheffield by canvas-covered wagon in February 1816. They were the first entire family to settle there. Their farm was located on French Creek near the intersection of Abbe Road and Colorado Avenue. Mary's brother was Capt. John Day, founder of Sheffield. The Roots' gravestones are pictured here in Pioneer Cemetery.

Capt. Aaron Root (1801–1865). Aaron, the eldest son of Henry and Mary (Day) Root, was 14 when the family arrived in Sheffield. His grandfather and namesake, Col. Aaron Root, served with the Massachusetts militia during the Revolutionary War. Once Aaron saw Lake Erie, he became enraptured with life on the water, eventually becoming a noted master of sailing ships and early steamers on the Great Lakes and the Atlantic Ocean.

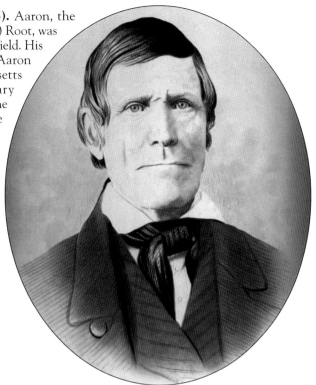

Capt. Aaron Root House. Captain Root constructed this late-1830s Greek Revival–style farmhouse on land settled by his parents, Henry and Mary (Day) Root, in 1816. Unfortunately the house has now fallen into disrepair. In 1840, Aaron sold 50 acres to John Forster, a Bavarian immigrant, initiating the Catholic community in Sheffield. Five years later, he sold another acre to this growing community to build the first St. Teresa Church.

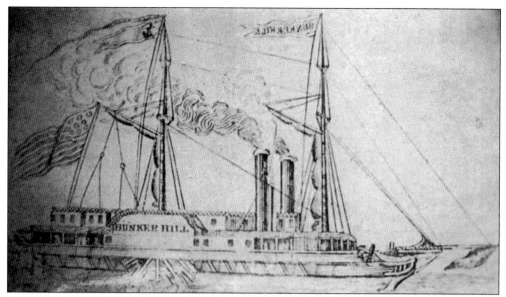

STEAMSHIP BUNKER HILL. Learning the seaman's trade at an early age, Capt. Aaron Root eventually operated and then owned several Great Lakes ships from 1825 to 1859. The 154-foot *Bunker Hill*, built on the Black River in 1837, is the first steamer he owned, and he used it to transport runaway slaves from the Jabez Burrell House in Sheffield to freedom in Canada on the last leg of the Underground Railroad.

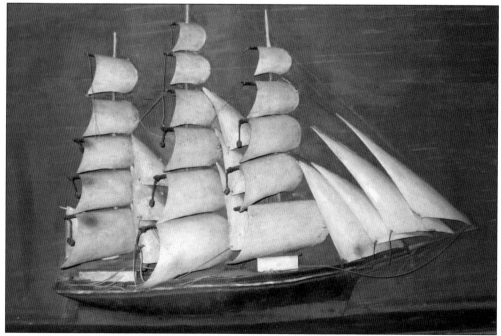

BARKENTINE *WM. S. PIERSON*. Capt. Aaron Root's final maritime adventure was sailing from Lorain to England via an early Welland Canal. This ship was built in Sandusky in 1859 by Captain Root and his associates. The crossing, with a cargo of gunstocks and barrel staves, was successful and prosperous, but the return voyage was stormy, and the ship sprang a leak. This model was made at the time of the sailing.

CAPT. AARON ROOT'S GRAVESTONE.
Captain Root died in 1865 while living in the Douglas Smith house on North Ridge with his wife, Esther Buck (1818–1872). Aaron and Esther are buried side by side in nearby Garfield Cemetery. They had nine children, five boys and four girls. Two of their sons, Edward and Henry, fought in the Civil War as sergeants in the Union army.

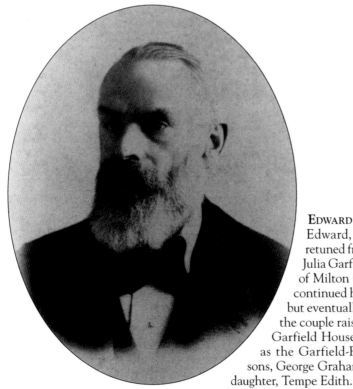

EDWARD ROOT (1834–1897). When Edward, son of Capt. Aaron Root, retuned from the Civil War, he married Julia Garfield (1841–1923), the daughter of Milton Garfield. For a time, Edward continued his father's maritime business, but eventually he retuned to the land, and the couple raised their family in the Milton Garfield House, which is often referred to as the Garfield-Root House. They had two sons, George Graham and Henry Garfield, and a daughter, Tempe Edith.

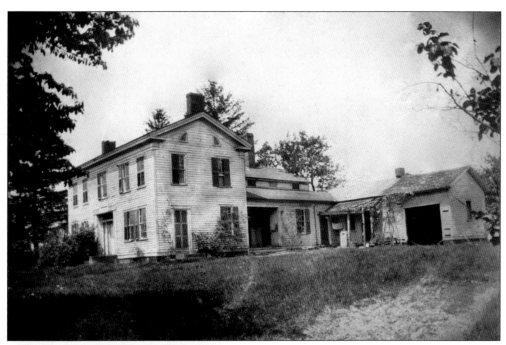

GARFIELD-ROOT HOUSE. Taken about 1912, this photograph shows the Milton Garfield House on North Ridge at about the time that Henry Garfield Root (1885–1971) married Ada Rider (1889–1977) and they became proprietors of the house. They raised a family of two daughters, Ruth Tempe and Esther Kathryne, and one son, Frank, here before the Great Depression forced them to sell the homestead in 1937.

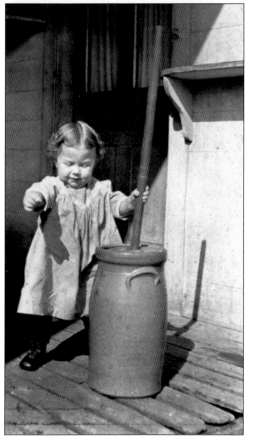

RUTH TEMPE ROOT (1913–2007). This photograph, taken in 1914 on the side porch of the Garfield-Root House, shows one-year-old Ruth working a butter churn. Her parents operated the family homestead, raising flax, corn, and row crops for sale in local markets. Ruth attended the small brick schoolhouse on North Ridge until Brookside School was opened in 1924. She was a member of the first senior class to graduate from Brookside in 1930.

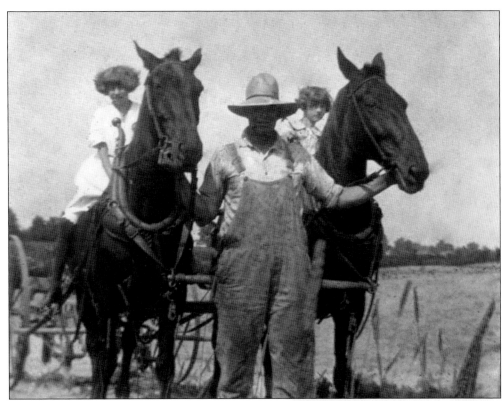

ROOT SISTERS ON TEAM OF HORSES. Ruth Tempe Root (left) and her sister Esther Kathryne Root ride on their uncle George Root's team of farm horses. The family homestead in 1923 encompassed some 100 acres of land on both sides of North Ridge Road (now Detroit Road). The road was merely hard-packed sand at that time and was periodically smoothed with a horse-drawn grader.

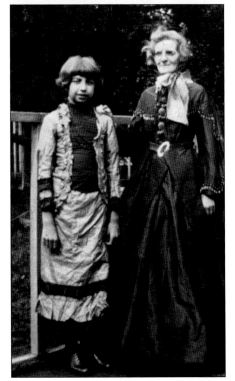

GARFIELD-ROOT FAMILY HISTORIC DRESSES. In 1924, women of the Garfield-Root family were dressed up in their ancestors' gowns. Ruth Root (left) is in a dress that belonged to her aunt Tempe Edith Root, while Belle Root is wearing the wedding dress of her mother-in-law, Julia (Garfield) Root. The rich chestnut-brown wedding gown, made in Chicago, is presently in the collections of the Sheffield Village Historical Society.

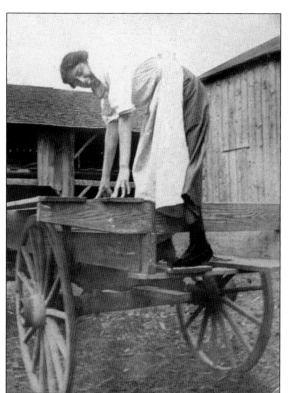

GEORGE AND HENRY ROOT BARNS.
This photograph, taken about 1914, shows the two barns owned by brothers George and Henry Root at the Milton Garfield homestead. Henry's wife, Ada, is climbing aboard a hay wagon. In October 1918, lightning struck George's barn and set it on fire. The fire quickly spread to Henry's barn, and both burned to the ground, killing one of the horses.

GARFIELD-ROOT BANK BARN. When the large barns at the Garfield-Root farm burned in a lightning storm in 1918, Henry Garfield Root built this small bank barn from timbers salvaged from the fire and logs cut in his woodlot. Originally a temporary replacement, it still stands. The wall studs are 4-by-4-inch chestnut posts, and the floor beams still have bark. SOHIO (Standard Oil of Ohio) was the fuel-delivery company.

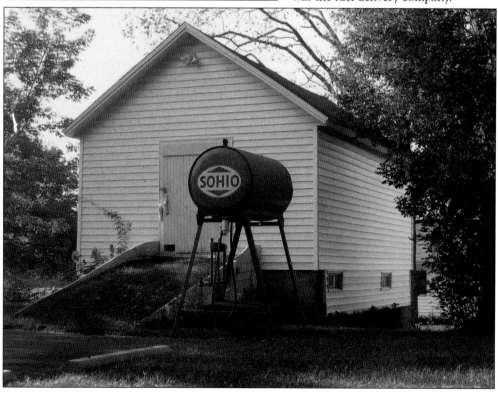

New Barn at Garfield-Root Farm. Following the 1918 fire that destroyed his and his brother's barns, Henry Garfield Root constructed a small bank barn adjacent to the main house. This served as a stable and hay barn until the property was sold in 1937. In 2000, members of the Garfield-Root family reacquired the property, and in 2005 built the barn pictured here as a reconstruction of the one lost in the fire.

George and Belle Root. This photograph was taken in 1907 to commemorate the wedding of George Root (1874–1944) and Belle Collins (1879–1966). George was the eldest son of Edward and Julia (Garfield) Root and a grandson of Milton and Tempe (Williams) Garfield. George inherited the portion of his grandfather's homestead south of Detroit Road.

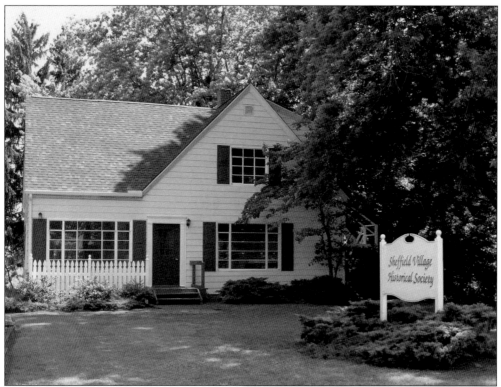

George Root-Walter McAllister House. In 1914, George Root removed the small west wing of his grandfather's house (Milton Garfield) and moved it across the road to his property on the south slope of North Ridge. This became the nucleus of his home that was expanded by Walter McAllister in the late 1930s. Today this building serves as the home of the Sheffield Village Historical Society.

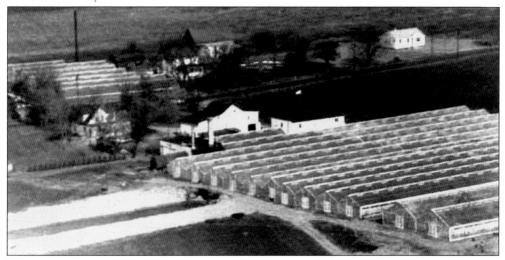

McAllister Greenhouses, Aerial View. After acquiring the land on the south slope of North Ridge from George and Belle Root in 1937, Walter McAllister set about to construct 2.6 acres of greenhouses over the next 10 years. The George Root-Walter McAllister house can be seen at the far left of the photograph. The Daniel Garfield house and barn are at the top center.

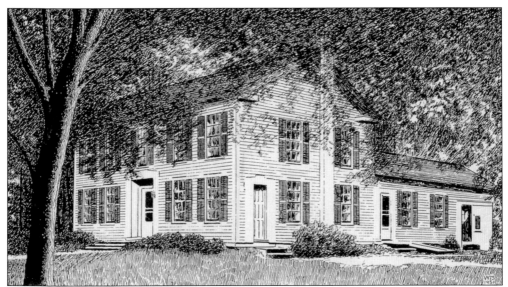

WILLIAM H. ROOT HOUSE, 1850. In 1816, William H. Root (1803–1889), along with his brother Aaron Root, walked the nearly 500 miles from the old Sheffield in Massachusetts to the new Sheffield in Ohio. Around 1850, he built this elegant Greek Revival–style home on a Lake Erie bluff at the foot of Root Road (named in his honor). William served as Lorain County auditor from 1855 to 1861.

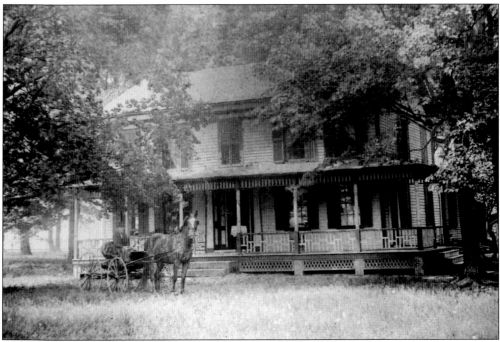

ORVILLE ROOT (1837–1919). Orville Root, son of William, sits on a buckboard in front of the house built by his father. Orville constructed the Victorian-style porch across the front. He was a banker and, as did his father, served as Lorain County auditor. Interestingly, he had purchased tickets for the return maiden voyage of the *Titanic* and was waiting in New York City in April 1912 for the ship that never came in.

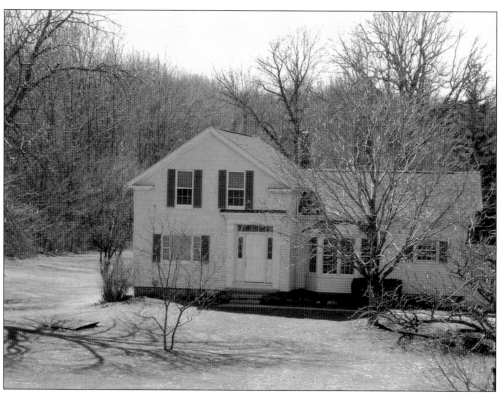

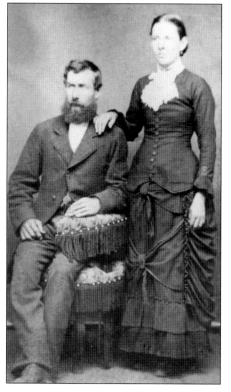

Mathias Schueller House. Located at 1148 Abbe Road, this 1848 Greek Revival–style farmhouse was built by Mathias Schueller (1811–1869), one of the founders of St. Teresa Church, and his son Peter. Typical of houses of this period and style, there is a two-story, gable-roofed main section with an attached wing. The family purchased the 55-acre plot in 1845 and lived in a log cabin until the house was built.

Peter and Margaret Schueller. This 1876 wedding photograph is of Peter Schueller (1847–1927) and Margaret Kelling (1854–1936). They inherited the Mathias Schueller house on the death of Peter's mother, Marie Katharina Schueller, in 1885. Their daughter Bertha Schueller (1897–1993) married Edward Mackert (1893–1959) in 1914, and the couple established Mackert's Dairy in the 1930s.

TOWNSHEND HOUSE. This *c.* 1855 Greek Revival–style farmhouse was built by Joseph Townshend on North Ridge. A notable feature is the elaborate bracketed porch of Italianate style. The interior has two white marble fireplaces and colorful ceiling rosettes. The house and 72-acre farm were acquired by Andrew and Clara Mackert in 1910. Their daughter Alice married Charles DeChant in 1935, and they raised their four children here.

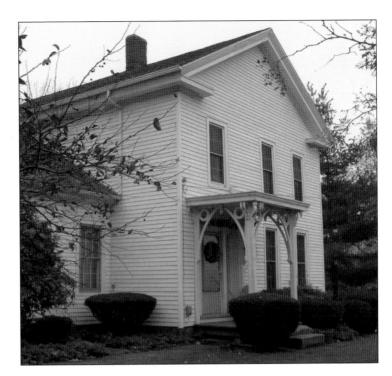

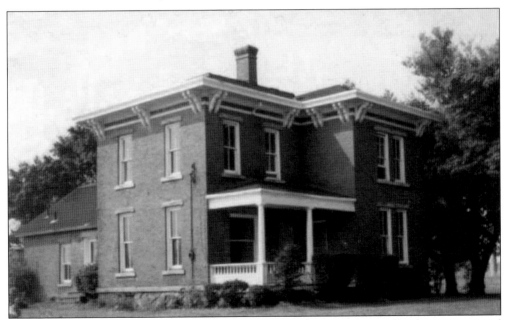

GEORGE MOON HOUSE. This attractive Italianate-style farmhouse on Detroit Road was constructed by George Moon in 1855. A front porch with Doric columns was added in 1875. George was the son of Oliver Moon, one of Sheffield's original pioneers. Subsequently the home was owned by William Wilder (1881) and the Gubeno-Gornall family (1915). Unfortunately this classic house was demolished in 1990 to make way for two fast-food restaurants.

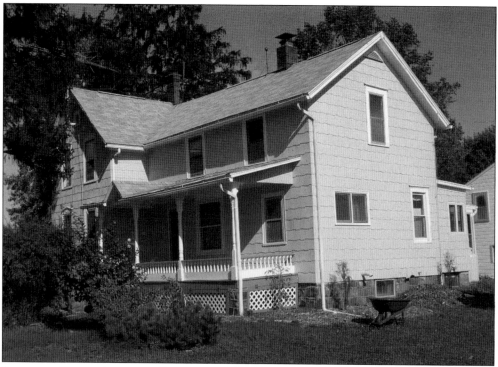

SCHWARTZ-BLAHA-ACKERMAN FARMHOUSE. This Vernacular-style farmhouse on Abbe Road was built in 1860 by John Schwartz, the son of Bavarian emigrants who established the family farm in 1845. The house plan is a front gable with a side wing. An elaborate porch with decorative railing and roof supports graces the front of the house. Members of the fifth, sixth, and seventh generations of the original family live in this home.

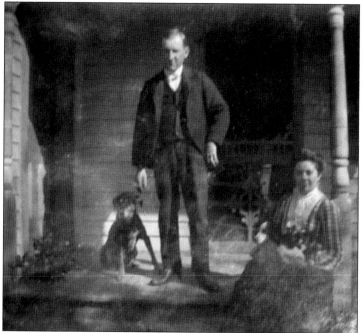

GEORGE AND MARGARET (GUBENO) SCHWARTZ. This *c.* 1910 photograph shows George and Margaret, with their dog Bippus, on the front porch of the house built by his father, John Schwartz. George Schwartz (1873–1940) became proprietor of the family farm upon the death of his father in 1901. His daughter Frances (Schwartz) Blaha and her husband, Rudy, took over the operation of the farm when George passed away.

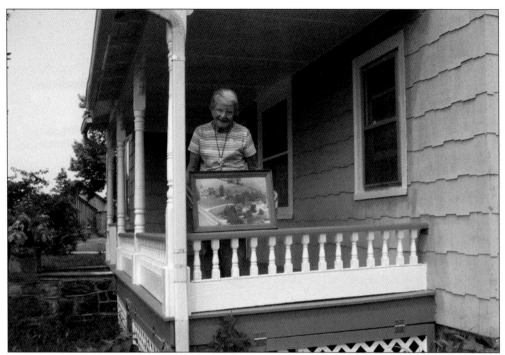

Porch of Schwartz-Blaha-Ackerman Farmhouse. Jean, daughter of Frances and Rudy Blaha, married Fred "Jake" Ackerman in 1961, and they became proprietors of the family farm on the death of Jean's parents. In this view, Jean is holding a 1952 photograph of the farm, showing the outbuildings and large pond. Each October, Jean organizes Apple Butter Day at the farm, which her children have nicknamed "Ackerosa."

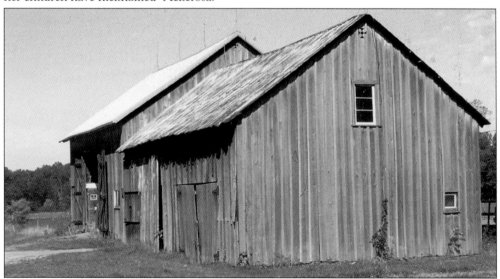

Barns on the Schwartz-Blaha-Ackerman Farm. These buildings are 150 years old, dating back to the early days of the farm. They are still in use for livestock, poultry, and hay storage. The Maltese cross–shaped opening in the gable was cut to allow owls to enter for control of rodents. This farm is one of the last remaining in Sheffield Village with a complete complement of farming activities.

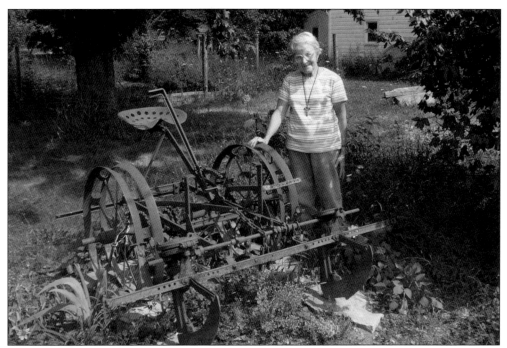

HISTORIC PLANTER. This historic farm implement at the Schwartz-Blaha-Ackerman farm is one of the many reminders of the Bavarian farm community that settled along Abbe Road and Colorado Avenue in the mid-1800s. Jean Ackerman, standing beside the planter, is a fifth-generation proprietor of the farm. Daily she feeds her chickens, waters her hogs, tends to her cows, and looks after her gardens.

FARM POND. Jean Ackerman's son Paul manages the aquatic habitats at the Schwartz-Blaha-Ackerman farm. Not only does he practice aquaculture in this large pond, but he has constructed small ponds for several varieties of turtles. In September 2007, Paul was amazed when a rare bloom of freshwater jellyfish (*Craspedacusta sowerbyi*) appeared in the large pond.

ACKERMAN FARM TRACTORS. This fleet of farm tractors at the Schwartz-Blaha-Ackerman farm on Abbe Road was assembled by Jean Ackerman's son Max. From left to right, it includes a 1956 Ford model 860, a 1948 Ford model 8N, and a 1953 Farmall Cub. All of these vintage tractors were restored by the Ackerman family.

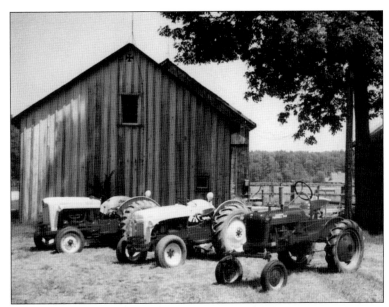

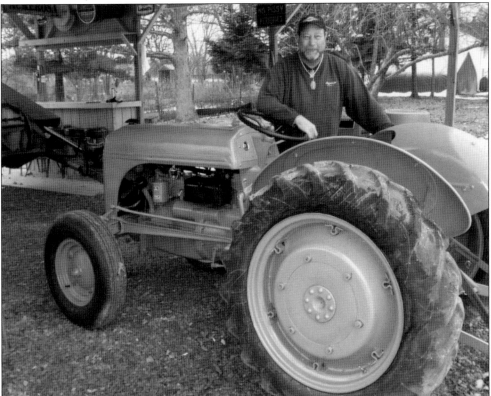

1941 FORD-FERGUSON MODEL N9 TRACTOR. Restored by Max Ackerman, this model was produced from 1939 to 1941, then again from 1945 to 1947. Production was halted during World War II, but a similar model (N2) was manufactured for military use. Before 1939, the Ford Motor Company made a tractor called a Fordson. In 1947, Ford and Ferguson split, and from 1948 to 1953 Ford made a model 8N tractor.

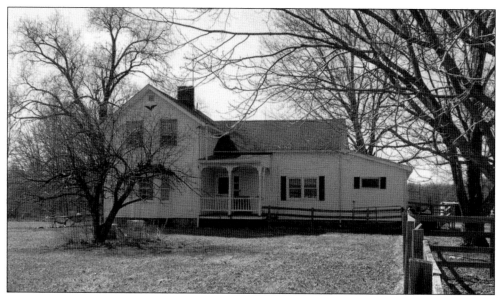

FORSTER-SCHUELLER HOUSE. This Vernacular-style farmhouse, with front gable and side wing, was built in the 1850s on Abbe Road near St. Teresa Church. The veranda features open wood railings, spindle posts, and covered brackets. Fieldstone was the original foundation material. John Forster purchased the land on which the house stands in 1840. The 1896 *Lorain County Atlas* shows the Schueller family as the owners of the property.

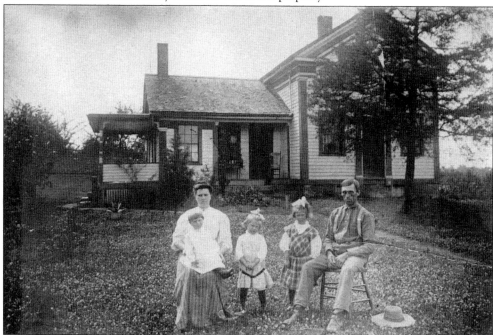

GUBENO-KRIEBEL HOUSE. This 1860s Greek Revival–style farmhouse was built on Abbe Road by Andrew Gubeno. Andrew's granddaughter Katherine married Simon Kriebel in May 1901, and they raised their family of nine children in this house. The photograph, taken in 1907 in front of the house, shows Katherine and Simon with three of their children—Lucille (left), Alma (center), and Hilda. In addition to farming, Simon operated the village's road grader.

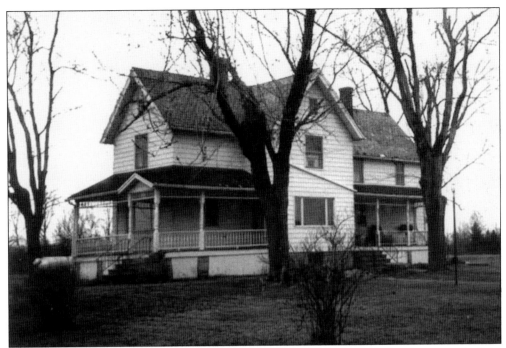

ANTON JUNGBLUTH HOUSE. This two-story, wood-frame Vernacular-style farmhouse was built by Anton Jungbluth in 1900 on Abbe Road and torn down 100 years later. A prominent feature was an expansive front porch that extended across the east side and one-third of the way along the north side of the house. It was highlighted by decorative railings, roof support posts, and overhead trim. A rear porch, also on the north side, exhibited similar design features.

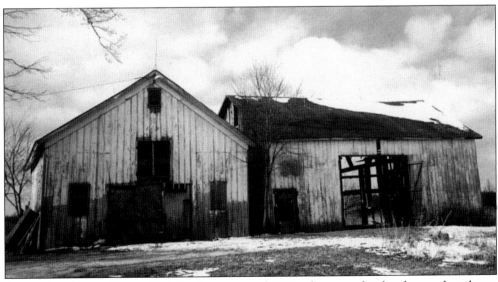

ANTON JUNGBLUTH BARNS. Built by Anton around 1900, adjacent to his farmhouse, these barns incorporated stalls for livestock as well as storage areas for grain, hay, and implements. Anton emigrated from Prussia with his parents in 1856 at the age of five. He and his wife, Catherine, raised six children on the farm. The house and barns were one of the finest examples of early-20th-century farm architecture in Sheffield.

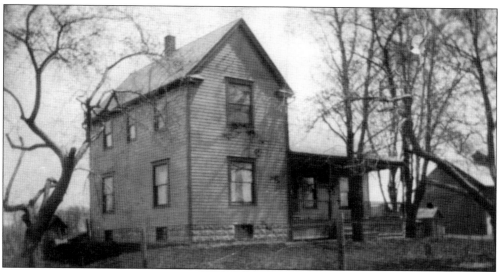

BERNARD JUNGBLUTH HOUSE AND BARN. Bernard, better known a "Barney," was the second son of Anton and Catherine Jungbluth. This 1912 Vernacular-style farmhouse exhibits some elements of Classical Revival style, particularly in the partial eave returns on the front gable. The large barn located south of the house was partially town down in 1976. Barney and his wife, Anna Webber, raised a family of eight children on this farm.

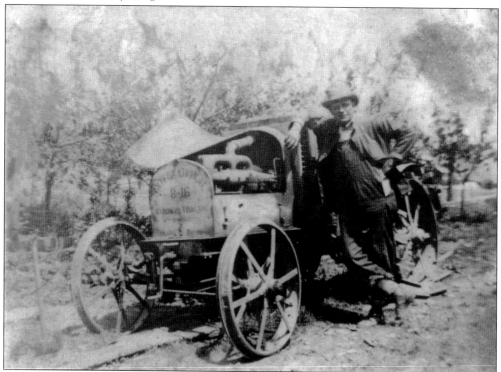

INTERNATIONAL 8-16 KEROSENE TRACTOR. Barney Jungbluth rests against his tractor in the late 1930s. The Barney Jungbluth farm was located on Abbe Road just south of the French Creek Road intersection. The 60-acre farm included grain fields, row crops, a large vineyard, an orchard, and dairy cows. A large metal silo once stood in front of the hay barn.

BARNEY'S BONDED WINERY. When Prohibition was repealed, Bernard Jungbluth established Barney's Bonded Winery. He produced and bottled Ohio concord wine with an alcohol content of 13 percent by volume. Barney provided home delivery, and on the same route his family would dispense both wine and milk. His daughter Gladys, one of the delivery girls, is shown at right in the late 1930s next to the winery's roadside sign.

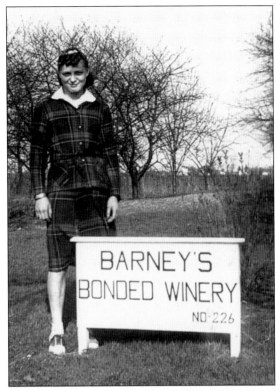

WISNIESKI HOUSE. This tidy Craftsman bungalow–style house was built in the 1920s by John Polesko. Located on East River Road adjacent to the French Creek Business Park, this has been the dwelling of the Kenneth and Gladys (Jungbluth) Wisnieski family since 1948. Here they raised four daughters and two sons. When first married, Kenneth and Gladys lived in the Jabez Burrell House while Gladys cared for Tempe (Garfield) Burrell.

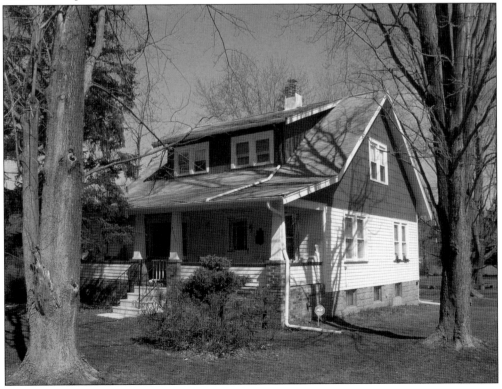

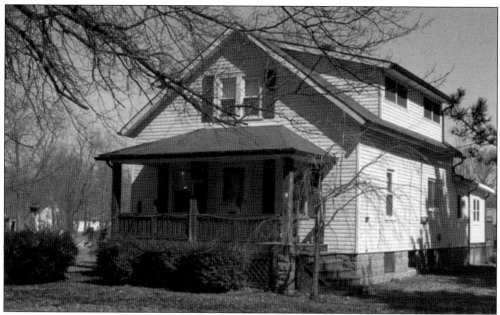

Guy Ferguson Farmstead. In 1920, the Farm Realty Company initiated the first real estate development in Sheffield Village, known as Acre Farms, by acquiring a 108-acre tract of land. The tract was divided into several-acre plots, and dedicated avenues were laid out. The Ferguson farmstead, at the corner of East River Road and Walnut Avenue, was the first to be built as a comprehensive small-scale farm, including livestock, poultry, and vegetable crops.

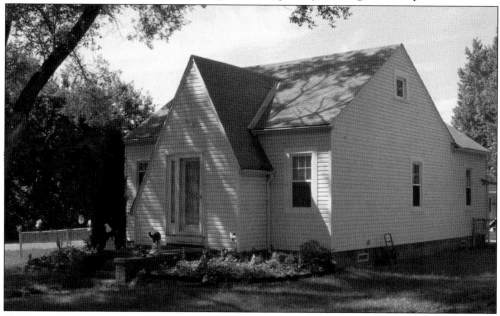

The Claremont. From 1908 to 1940, Sears, Roebuck, and Company sold about 75,000 package homes throughout the country. Several of these mail-order kit homes were built in Sheffield Village. This one on Day Street was built in the 1930s. The 1928 Sears catalog advertised "The Claremont" at a price of $1,353, delivered by railway. A homeowner could save about 30 percent by self-assembling a Sears house.

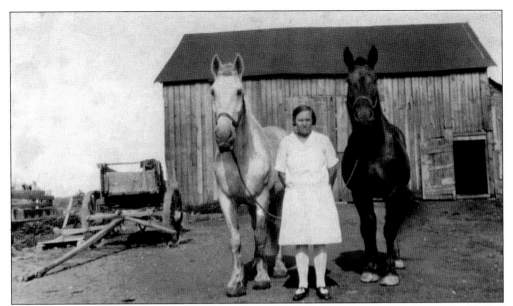

GERBER-CUNNINGHAM FARM. This farm was located on East River Road near the eastern bluff of the Black River. This photograph shows Lydia (Gerber) Cunningham holding the reins of two of her farm horses in the 1930s. Members of this family still live on the property and are active in the administration and exhibits at the Lorain County Fair in Wellington, Ohio.

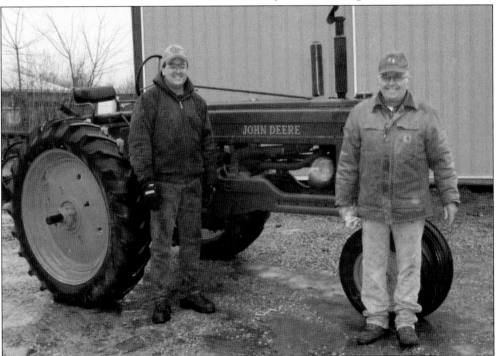

JOHN DEERE MODEL B TRACTOR. Rick Ternes (left) and his father, Tim, restored this 1951 John Deere tractor at their farm on East River Road. Over a million of these model tractors have been manufactured. Rick and Tim also restored a 1954 International Harvester McCormick Farmall H tractor that once belonged to the Burrell family. Both tractors are in use on their farm.

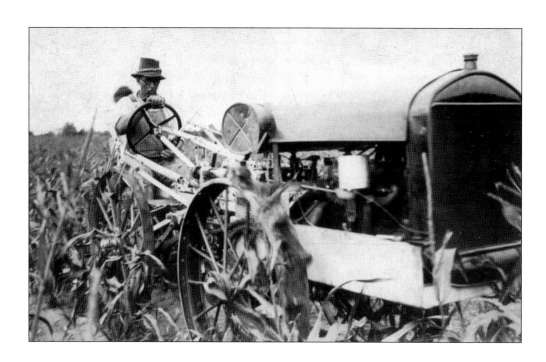

CLYDE MCALLISTER TENDING FARM FIELDS. Clyde McAllister, Sheffield Village's first mayor, is shown here operating his steel-wheeled tractor in a cornfield on his North Ridge farm (above) and cultivating his crop with a gasoline powered cultivator (below) in the early 1930s. Clyde was elected for seven terms as the mayor of Sheffield, serving from 1934 to 1947. His sons Walter and Kenneth were also farmers, and eventually the family farm grew to nearly 70 acres. In 1957, Walter McAllister was elected as the fourth mayor of the village. The McAllister farm was originally part of the Milton Garfield homestead.

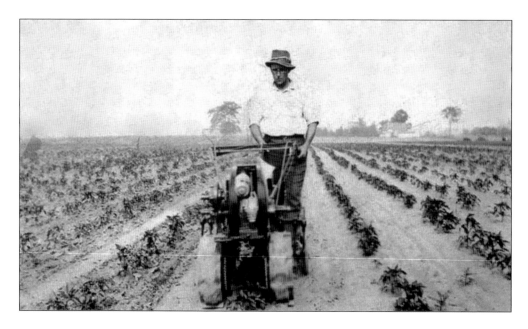

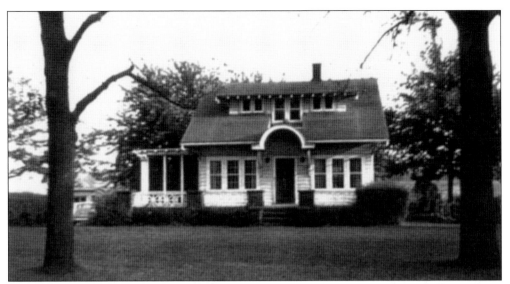

CLYDE MCALLISTER HOUSE. This Craftsman bungalow–style farmhouse at 4926 Detroit Road was built in the late 1920s by Clyde and Louise McAllister. A unique feature is the semi-circular arch over the main entrance supported by curved brackets. When the Village of Sheffield was formed in 1934, Clyde McAllister was elected as the first mayor. Because the community did not yet have a village hall, the first council meetings were held in his farmhouse.

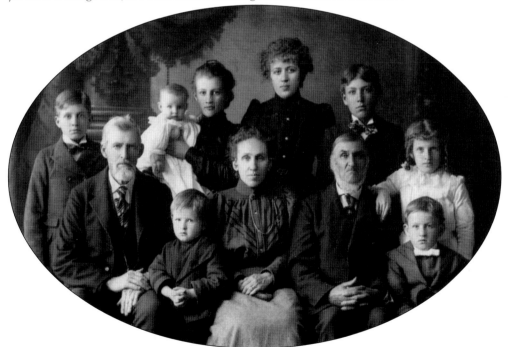

NATHANIEL DUNFEE FAMILY. Nathaniel settled in Sheffield Township on North Ridge in 1864. His family is shown here in 1900. They are, from left to right, (first row) Nathaniel Dunfee, Roland Dunfee, Sarah (Turner) Dunfee, Henry Turner, Jenny Dunfee, and Raymond Dunfee; (second row) Roy Dunfee, Sadie Dunfee, Pearl Dunfee, Hattie Dunfee, and Ralph Dunfee. Sarah (Turner) Dunfee was Nathaniel's wife and Henry Turner, who lived in Sheffield, was Nathaniel's father-in-law.

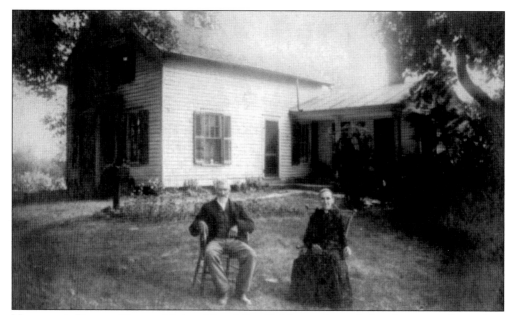

NATHANIEL DUNFEE HOUSE. Nathaniel and Sarah's Vernacular-style farmhouse was located on North Ridge in Sheffield Township, west of the Black River. They farmed the land on slopes of the ridge for 45 years and had four sons and four daughters. Nathaniel was born near the shore of Lake Erie at Angola, New York, in 1835. He died in his Sheffield home at age 74.

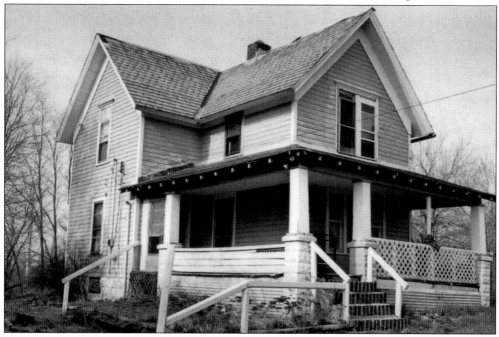

RAYMOND DUNFEE HOUSE. Raymond (1892–1994), second-youngest son of Nathaniel Dunfee, married Ann Richter in 1913. Paul and Roy Taylor (grandsons of Daniel Garfield) built this Vernacular-style farmhouse for them in 1937 on land Raymond had acquired from the estate of John B. Garfield, cousin of Milton Garfield. Located on the ridge crest at the northeast corner of Detroit and East River Roads, it was torn down in 2003.

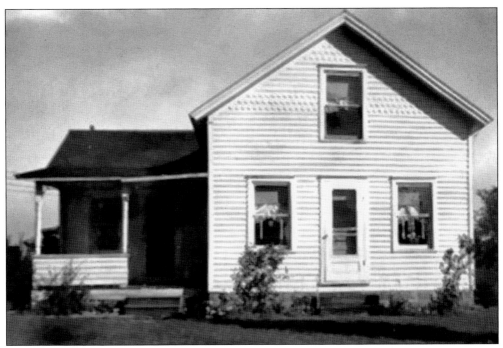

REYNOLDS-HAMMER HOUSE. This small Folk Victorian–style house was built around the 1870s. The house features elaborate trim on the porch column and scalloped shingles on the front gable. The residence is on the original North Ridge estate of John Bird Garfield and is believed to have been built for his daughter Mary Hulda (Garfield) Reynolds or his granddaughter Mabel Edith (Reynolds) Hammer.

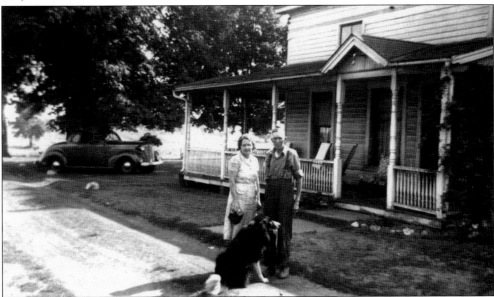

EDWARD AND ZELMA MINARD. Edward (1882–1947), son of Civil War veteran Lenza Minard, lived his entire life in the Douglas Smith house (see page 17). This late-1930s photograph shows Edward and his wife, Zelma, at the east side porch. The house, as originally built in 1833, most likely did not have this elaborate porch.

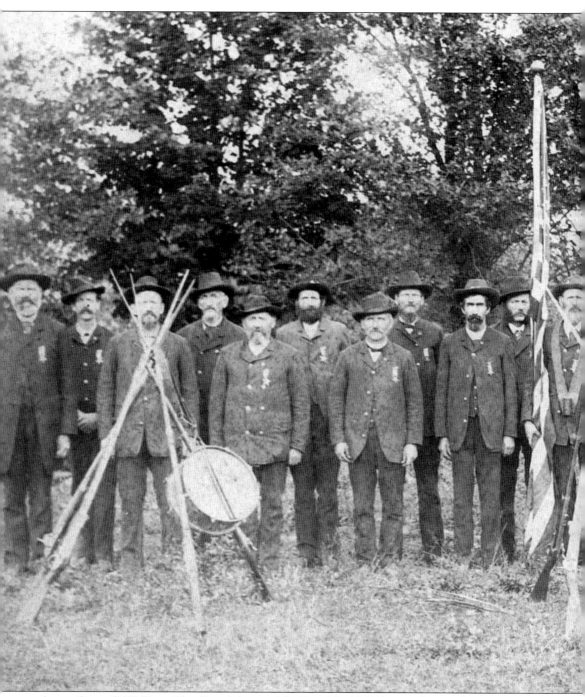

AVON, OHIO, GAR POST. The Grand Army of the Republic (GAR) was a fraternal organization in the United States. Membership was open to soldiers and sailors who served credibly in the American Civil War. In 1894, when this photograph was taken, the GAR had 400,000 members. Lenza Minard, who lived in the Douglas Smith house on North Ridge at that time, is the

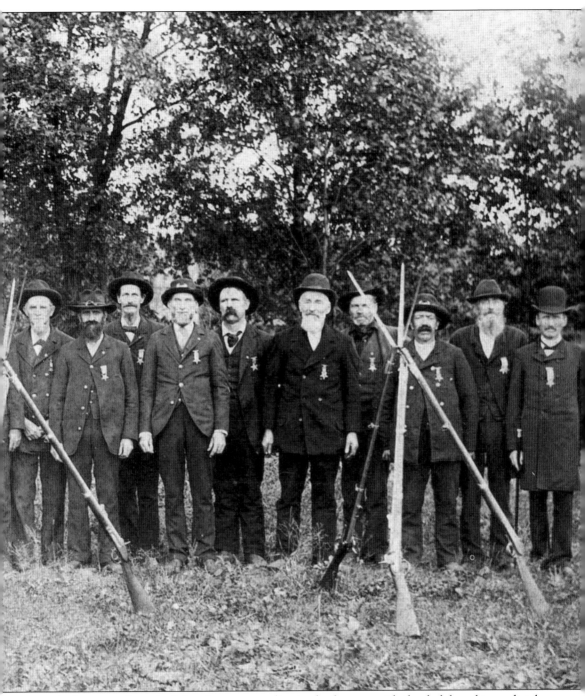

ninth veteran from the left—the man standing in the first row with the dark beard immediately to the left of the flag. During the Civil War, Lenza served with Company C of the 52nd Regiment and Company I of the 176th Regiment of the Ohio Volunteer Infantry.

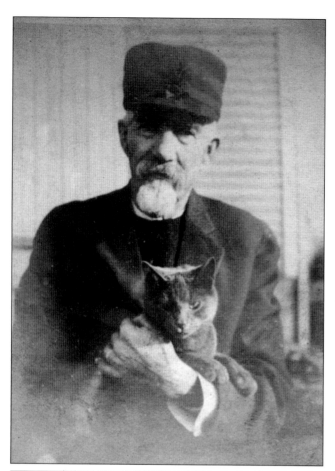

LENZA MINARD AND CAT. Lenza (1847–1824) and his wife, Cornelia (Taft) Minard (1849-1936), resided in the Douglas Smith house on North Ridge for several decades. After returning from service in the Union army, he farmed the land surrounding the house. Set back from the road, the residence has an attractive location and is one of a cluster of historic homes on the north side of Detroit Road.

BARTININSKI HOUSE. This one-and-a-half-story house, located at 5421 Colorado Avenue, has a gambrel roof, where the two side slopes of the roof are composed of a shallower slope above a steeper one. The structure is believed to have been built in the 1920s. Laura (Bell) Bartininski, born in 1925, grew up in this home. The surrounding land was part of the Bungart farm in the 1870s.

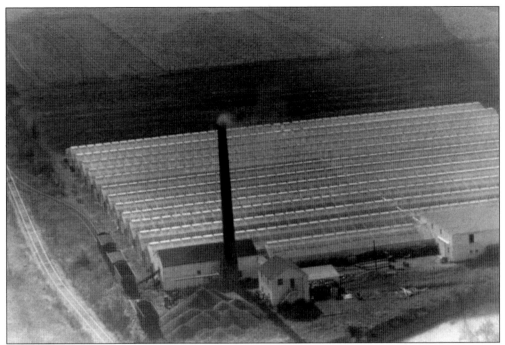

JOHN HOAG GREENHOUSES, AERIAL VIEW. Located on Abbe Road south of Detroit Road, this greenhouse complex covered 4.2 acres of land in the 1940s and included a railroad siding for delivery of coal to fuel the boilers. John Hoag and his son Ellis "Bud" started the greenhouse in 1929 by placing 2.2 acres of farmland under glass at the southeastern corner of the village.

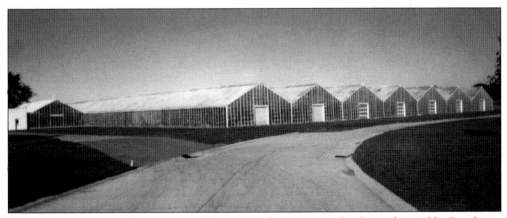

ROBERT HILTABIDDLE GREENHOUSES. These greenhouses were also located on Abbe Road, just north of the Hoag Greenhouses. The sandy soils of North Ridge proved ideal for growing tomatoes and other gourmet vegetables in greenhouses. Individual greenhouses were about 400 feet long and 32 to 36 feet wide. By the 1970s, ten such greenhouses occupied 24 acres in Sheffield Village and annually produced upwards of 600 tons of tomatoes, valued at over $3 million.

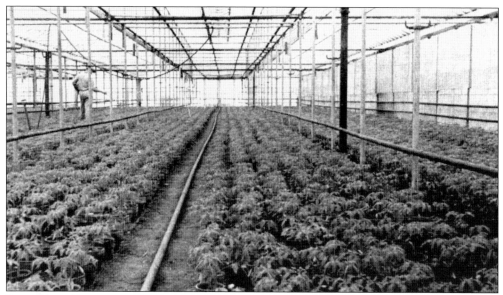

JOHN HOAG GREENHOUSES, INTERIOR VIEW. Annual greenhouse tomato production took place in two cycles. Seeds were started in hotbeds in October, and in December seedlings were planted in 200-foot-long rows. The tomato harvest began on Valentine's Day and continued for several months. The expired plants, 18 feet in length, were pulled in July and the ground sterilized with steam to kill fungus and weed seeds. Another cycle would then begin.

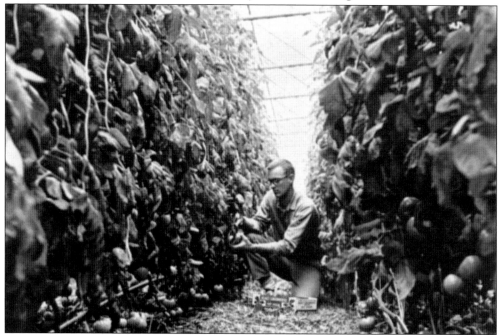

HARVESTING GREENHOUSE TOMATOES. John Hoag's grandson Jack is picking tomatoes in 1967. Typical greenhouse production yielded 18,000 baskets (about 8 pounds each) per acre. On June 8, 1953, a tornado hit Sheffield's greenhouses, destroying 75 percent of Hoag's houses; but with the help of neighboring operators, they were quickly rebuilt. Environmental regulations and competition from southern and foreign growers eventually ended this once flourishing industry.

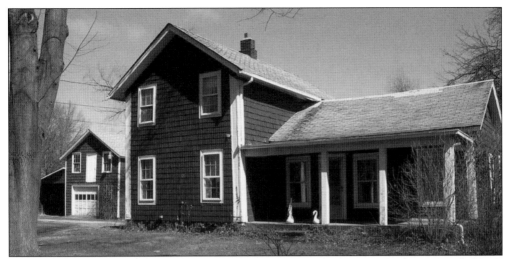

SMITH-KINNEY-ROOT FARMHOUSE. Douglas Smith and his son Perry built this Classical Revival–style farmhouse, a granary, and a large hay barn adjacent to a semi-circular driveway in 1857 on East River Road. In 1869, Judson Kinney, who sold the property to a steel company in anticipation of a new mill in 1917, acquired the farm. This was not to be, and in 1944, Henry Garfield Root and his wife, Ada, purchased the farm.

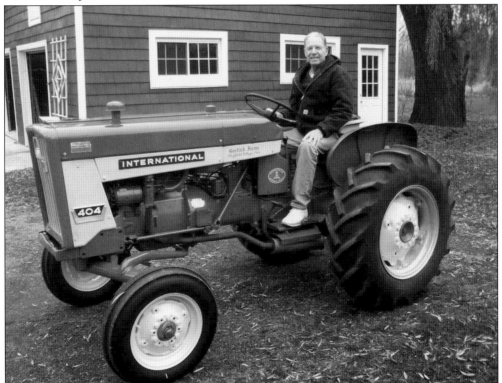

INTERNATIONAL 404 FARM TRACTOR. This tractor was purchased new by Edward Herdendorf in 1962 from the Elyria Implement Company for $2,600. Donald Hammer (driving) restored the tractor in 2009. The International 404 tractor is pictured here alongside the 1857 granary built by Douglas and Perry Smith at the Smith-Kinney-Root farm.

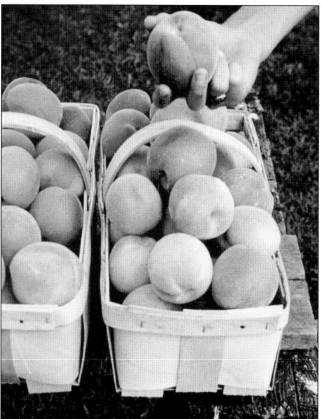

ROADSIDE GARDEN STAND. Roadside stands selling farm produce abounded in Sheffield Village during the 1940s and 1950s. This one, located on East River Road, has a display of pumpkins and watermelons. Other popular crops for sale included strawberries, blackberries, sweet corn, tomatoes, and peppers. The two young salesmen are Donnie (left) and David Hammer.

PEACH ORCHARDS. Because of Sheffield's proximity to Lake Erie, fruit trees, particularly peaches, thrive. Warm autumn waters give a longer growing season than in the southern parts of Lorain County. Cold lake waters in the spring keep the buds from coming out early. These peaches came from an 800-tree orchard on East River Road that operated during the 1950s and 1960s.

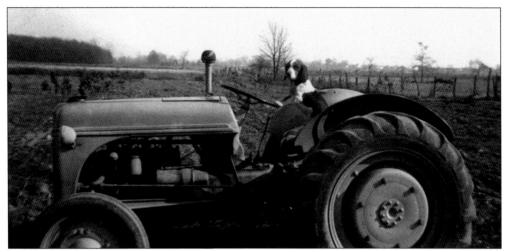

Ford-Ferguson Model 9N Farm Tractor. This early 1940s tractor was purchased in 1950 at Van Wert, Ohio, by Edward Herdendorf to tend his peach orchard on East River. Here the family dog, Snooper, takes his turn at cultivating the trees. It was said that his driving skills were only "marginal."

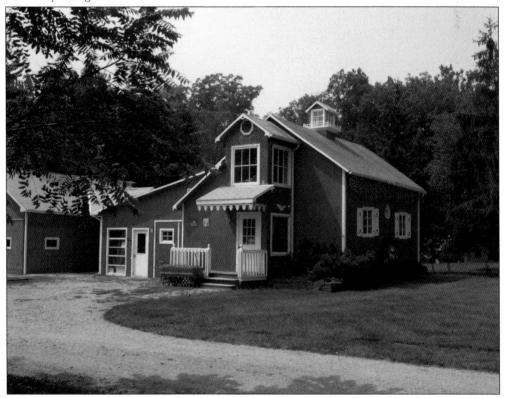

Klingshirn's Little Red Barn. This building was constructed as a granary by Capt. Aaron Root adjacent to his 1830s farmhouse. Elmer and Sandy Klingshirn restored the barn in the 1980s, and for many years it was open to the public as an antique and gift store at 5242 Colorado Road. This structure, included with the Capt. Aaron Root house, is one of 31 properties in Sheffield Village listed on the Ohio Historic Inventory.

CALEY HOUSE. This large Greek Revival–style farmhouse of the mid-1800s was later modified with the addition of a front gabled dormer and an expansive front/side porch. The Caley homestead is located on East River Road not far from the Thirty-first Street Bridge. Fred "Fritz" and Rachel (Anderson) Caley raised their large family there. The Caley family originated on the Isle of Man, an island in the Irish Sea between England and Ireland.

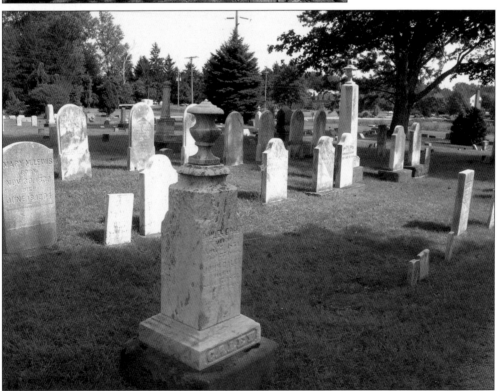

CALEY FAMILY CEMETERY PLOT. Twenty-four members of the Caley family are buried in Garfield Cemetery on North Ridge. A tragedy befell the family in 1854 when five members were stricken with influenza and died in rapid succession. Cemetery records show that 11 individuals died that year, the second highest in the long history of the cemetery.

NORTH RIDGE SOILS. The sandy soils on North Ridge are some of the most fertile and well-drained in Sheffield. The light-colored soil in the foreground is Oshtemo sandy loam, formed from ancient beach ridge parent material. The darker earth in the background is Mermill loam, a wetland soil formed in ancient lake deposits. Here Sheffield Township farmer Robert Betzel is planting sweet corn.

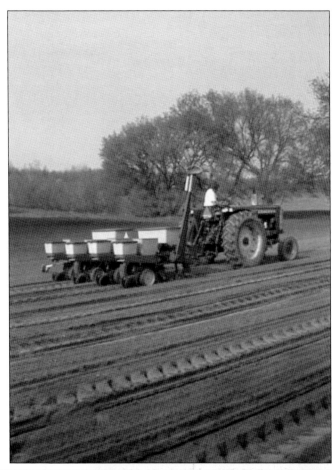

HARVESTING SWEET CORN ON NORTH RIDGE. Sweet corn is perhaps the most valuable cash crop grown on North Ridge. In the past, these fields were planted in grains and flax. Sheffield Township farmer Robert Betzel is shown here harvesting his corn crop in Sheffield Village. The corn is planted sequentially, so that each week during the harvest season a new field is ready to be picked.

NO-TILL FARMING. In recent years, no-till farming techniques have been employed in Sheffield Village to reduce soil erosion and the amount of fertilizer nutrients being carried to Lake Erie on soil particles. Sheffield Township farmer Robert Betzel is planting soybeans on North Ridge in this view. In addition to good conservation, this new practice can be a cost saver for farmers.

SOYBEAN FIELD ON NORTH RIDGE. This soybean field on the Milton Garfield farm was planted using the no-till technique. Rather than plow and disc the farm field, the method uses a drill to plant the seed through untilled soil. One drawback is that high levels of herbicides need to be applied to control unwanted weed growth.

Three

CHURCHES

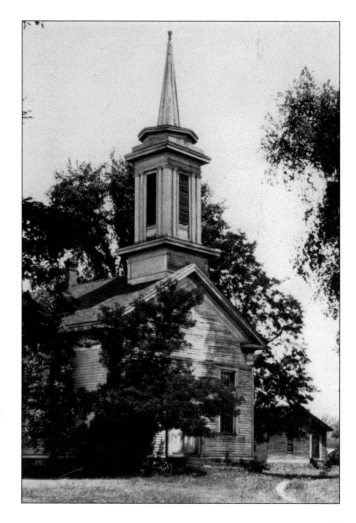

SHEFFIELD CONGREGATIONAL CHURCH. Built in 1852 to replace an 1818 log church, this elegant Greek Revival–style country church was located on East River Road, high on the bluff overlooking Sugar Creek. A long row of horse barns for use by the parishioners sat behind the church. Property for the church grounds was donated by the Burrell family.

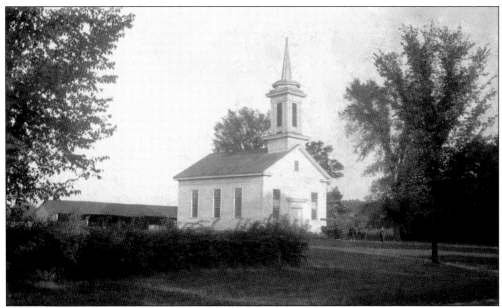

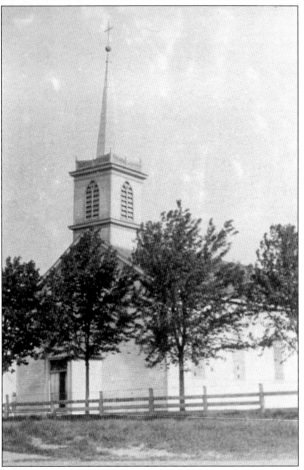

SHEFFIELD CONGREGATION CHURCH FACADE. The church had an entranceway with side pilasters supporting a decorative entablature over the door. The elaborate bell tower and narrow spire rose 50 feet above the ground. The final service was held in 1903, a funeral for 18-year-old Edna Crehore. The church was refurbished in 1915 for Sheffield's centennial celebration and torn down in the 1930s, but some foundation stones can still be seen.

ST. TERESA CHURCH OF 1852. German migration to Sheffield began in 1840, when John Forster of Bavaria arrived and purchased 50 acres of land from Capt. Aaron Root near the intersection of Abbe Road and Colorado Avenue. Here 20 German emigrant families established a log church in 1846. This was replaced by a church of wood frame construction in 1852. The structure featured a high spire and a belfry containing an 800-pound bell purchased by Fr. Dominic Zinsmayer.

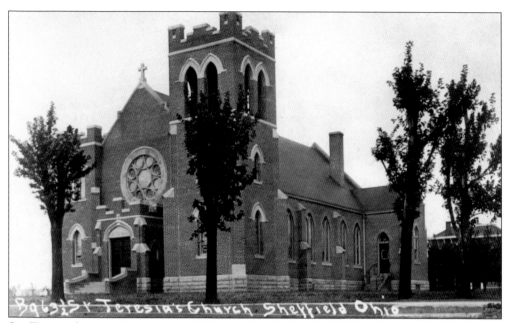

ST. TERESA CHURCH DEDICATION. A fire on Sunday March 3, 1907, destroyed the 1852 frame church during high mass. Parishioners carried pews, vestments, and the organ from the burning structure but watched the large bell crash to the ground. Plans for a Gothic-style church were drawn; red bricks kilned nearby, and a new church was completed in nine months. The first mass here was celebrated by Fr. Adam Senger and Bishop Joseph Koudelka on Christmas Day 1907.

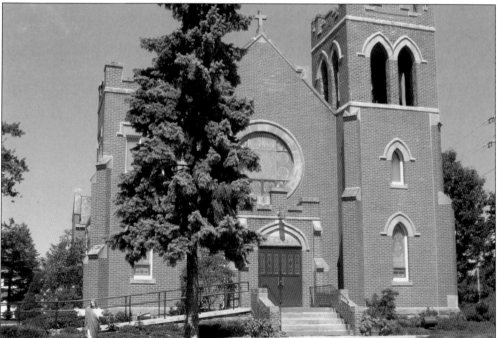

ST. TERESA OF AVILA CATHOLIC CHURCH. The new brick church measures 40 feet by 74 feet in a Latin cross plan. Between two facade towers, the structure rises to a gabled roof. The east tower continues as a belfry for an additional 25 feet.

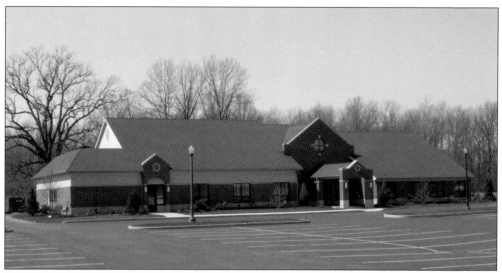

ST. TERESA CHURCH PARISH LIFE CENTER. In 2005, the parish constructed a large multipurpose building to the west of the church for religious education and social functions. Known as Avila Hall, the structure contains four classrooms (Matthew, Mark, Luke, and John) as well as a spacious meeting room and kitchen. This building replaced the wooden social hall that was purposely burned in 1987.

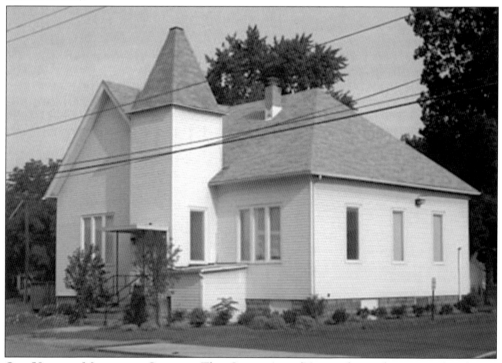

OLD VINCENT METHODIST CHURCH. This Queen Anne/Vernacular–style county church was constructed around 1910 on North Ridge, a short distance east of the Yellow Line streetcar tracks that provided a convenient connection between Elyria and South Lorain. The community of Vincent in Sheffield Township grew up around stop no. 7 of the "Yellow Line." The building now serves as nursery school.

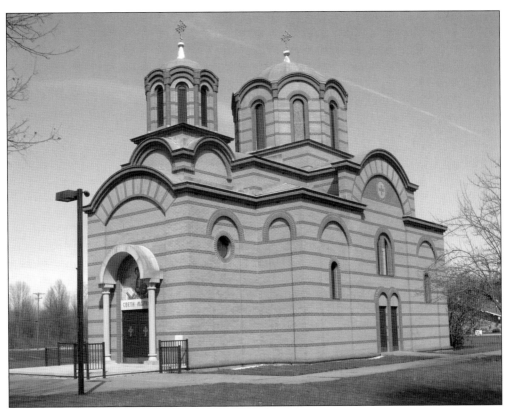

St. Mark Monastery Church. This attractive Serbian Orthodox church is located on Lake Breeze Road. Consecrated in May 1988, it is modeled after a 600-year-old church near Skopje, Macedonia. That church was completed in 1372 by Prince Marko, a hero of the Serbian people. The church leaders' vision is that the new monastery church will stand guard on the shores of Lake Erie for centuries to come, offering spiritual support.

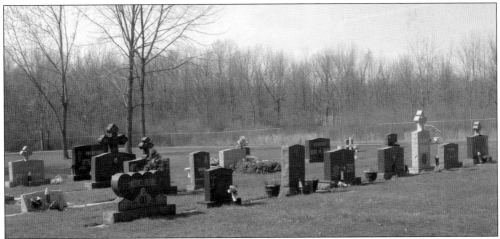

St. Mark Church Cemetery. Located on a large tract of land west of the monastery church, the relatively new cemetery has less than 100 graves. The stone monuments are of a modern design with artistic carvings and images. Most of the monuments are cut from granite rock of various geological formations yielding an array of stone colors.

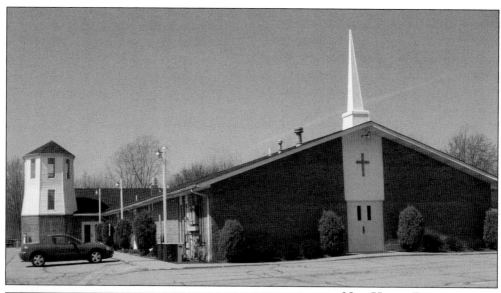

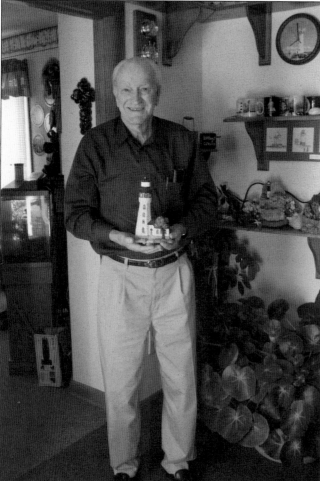

NEW HAVEN BAPTIST CHURCH. This yellow-brick church is located on the southeast corner of Abbe and French Creek Roads. The congregation was founded in 1952 in Avon, Ohio, as the Calvary Baptist Church. The present sanctuary was constructed in 1990. The current congregation has about 125 members. An attached church hall also serves as a voting precinct for Sheffield Village.

PASTOR, NEW HAVEN BAPTIST CHURCH. Pastor Richard White oversaw the construction of his church. Lighthouses have a special spiritual symbol for him, and he designed one for the south wing. It has three levels—pastor's office on the ground floor, a library and reading room on the second level, and an observation deck at the top for contemplation. In this photograph, Pastor White holds one of his many treasured lighthouse models.

Four

SCHOOLS

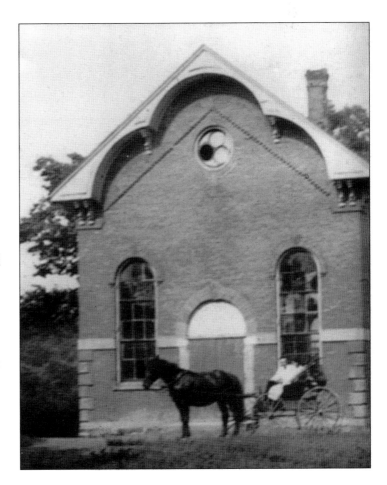

SHEFFIELD TOWNSHIP SCHOOLHOUSE NO. 1. This 1880 redbrick district school was located on East River Road near the Sheffield Congregational Church. Grades one through eight were taught on the main level, and the board of education occupied the basement. The first school in Sheffield was a log building on the south bluff of French Creek constructed in 1817. Church services were also held in this structure.

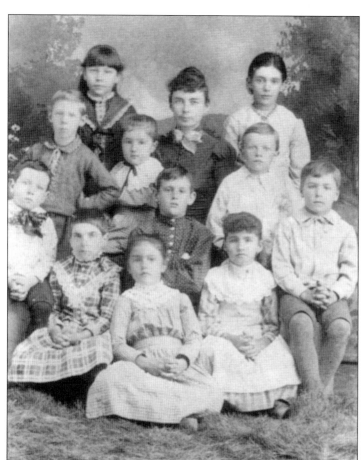

TEACHER AND STUDENTS, 1880s. This image of Sheffield Township District No. 1 School students and teacher Maude Day appears to have been taken in a studio. Maude, born in 1861, was the daughter of William Augustus and Mary (Steele) Day. After teaching for a number of years, she married George Day, son of James and Ann (Austin) Day, in 1901. Maude's mother also taught at this school.

TEACHER AND STUDENTS, 1893. Sheffield Township District No. 1 School teacher Mary (Steele) Day is surrounded by the 24 students enrolled in the school. A second teacher at the upper right is unidentified.

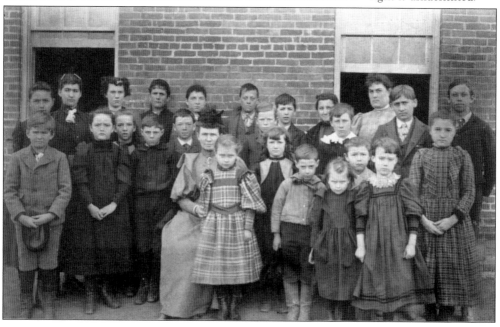

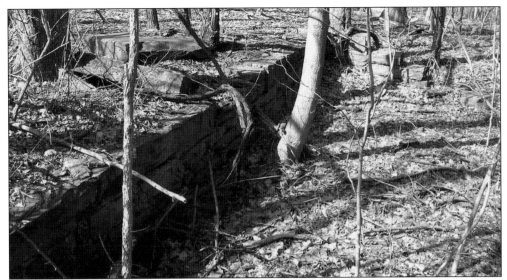

SCHOOLHOUSE STONE FOUNDATION. The 1880 district no. 1 schoolhouse was demolished in the late 1930s after sitting idle since Brookside School opened. The sandstone foundation blocks that formed the basement walls are still standing, and the brick that lined the top of the school's well can still be seen. The old school grounds are now within the French Creek Reservation of the Lorain County Metro Parks.

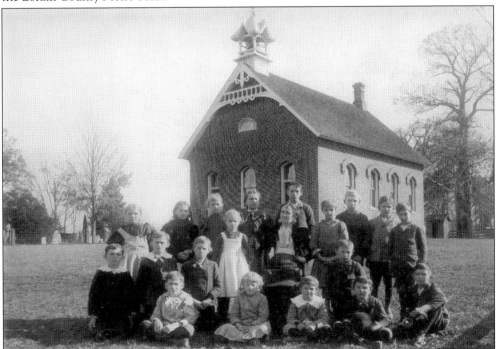

SHEFFIELD TOWNSHIP SCHOOLHOUSE NO. 2. Built in 1883, this district no. 2 schoolhouse is distinguished from typical late-19th-century one-room schools in that it has elaborate Queen Anne–style wood trim, especially at the peak of the front facade, and an ornate cupola. Designed by architect E. Terrell, it was one of eight redbrick township schools built before centralization in the 1920s. The school is shown here with the 1911 students and teacher.

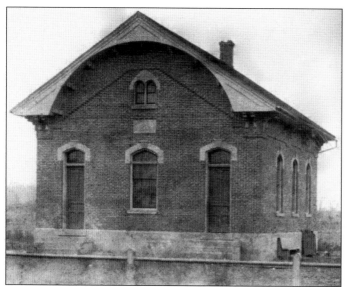

SHEFFIELD TOWNSHIP SCHOOLHOUSE NO. 7. This district school, built in 1880, was located at the crossing of Abbe Road and Colorado Avenue. Although it was a public school, it was built near St. Teresa Church mainly to serve the Catholic community. With the full knowledge and consent of the Sheffield Township Schools Board, Catholic lay teachers, the pastor, and sisters taught class at this school for over 40 years.

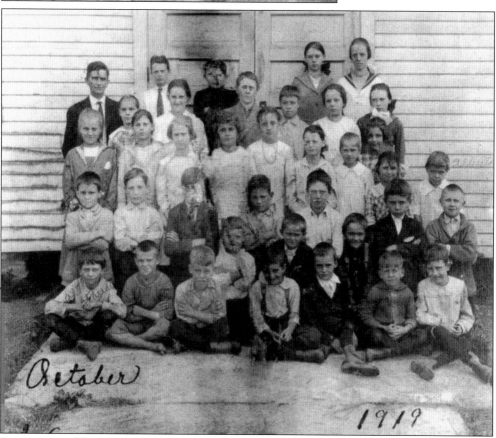

SCHOOLHOUSE NO. 7 STUDENTS, 1919. In 1845, the St. Teresa parish built a log schoolhouse where the cemetery is now located. Classes were held here for a few years, with Peter Laux serving as the teacher. Starting in 1880, Catholic students attended the district no. 7 school. This photograph shows the district no. 7 students in 1919, a few years before the school closed.

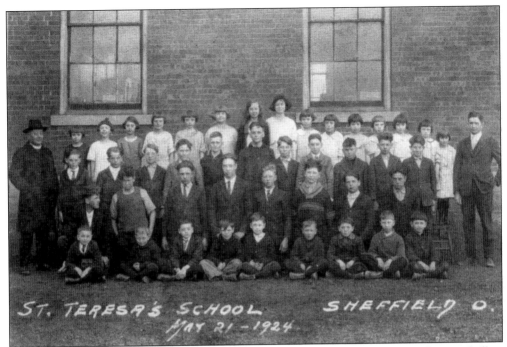

St. Teresa School, 1924. In 1922, the majority of the voters in Sheffield Township cast ballots for a centralized school, and plans to build Brookside School were formulated. District no. 7 school became surplus property, and St. Teresa Church was permitted to use the building rent-free as a Catholic parochial school starting in September 1922. In 1924, St. Teresa Church purchased the building for $100.

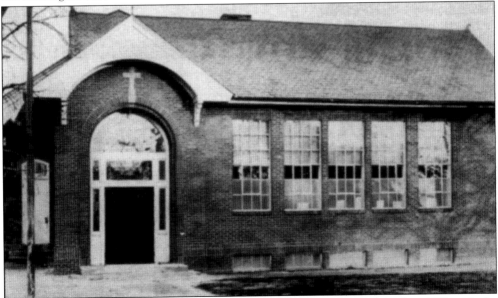

St. Teresa School, 1927. The old district no. 7 schoolhouse was enlarged in 1927 with the addition of a new classroom, two corridors, and a basement. Peter Rissman was the architect, and Peter Deitz served as general contractor; both were from Lorain, Ohio. The total cost of the project was $10,600. The name of school was officially changed to St. Teresa School.

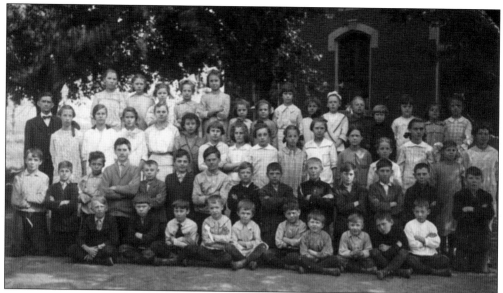

St. Teresa School, 1930s. By 1937, enrollment at St. Teresa School had risen to 59 pupils—36 boys and 23 girls. Sr. Mary Manuella served as local superior and taught grades five through eight, Sr. Mary Harold taught grades one through four, and Sr. Mary Nathalis was in charge of the kitchen.

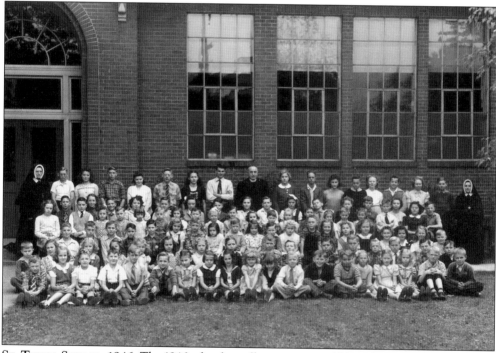

St. Teresa School, 1946. The 1946 school enrollment was over 100 students. By 1952, it jumped to 165, and a new wing with two classrooms was added. Enrollment peaked at 220 students in 1955, nearly double the building's capacity. The opening of St. Thomas School in Sheffield Lake to relieve the student pressure was the death knell for St. Teresa School. Declining attendance caused it to close in 1967.

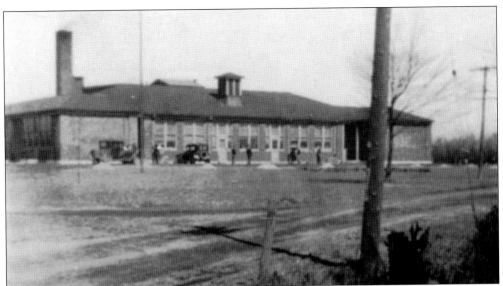

BROOKSIDE SCHOOL, 1920s. This school was built in 1923 as part of a Lorain County effort to centralize education and eliminate one-room district schools. Brookside received its name because the French Creek flows nearby. This photograph, taken a few years after Brookside School was opened, shows that Colorado Avenue (now Ohio Route 611) was only a dirt road at the time.

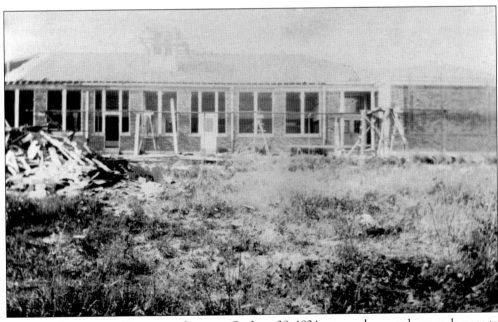

TORNADO DAMAGE AT BROOKSIDE SCHOOL. On June 28, 1924, a tornado caused severe damage to the new school. The roof and most of the windows had to be replaced. In an effort to keep it from buckling, holes were drilled into the gymnasium's hardwood floor to let water escape. Working industriously, repairmen had the building ready for fall classes. Sheffield had one fatality, but 80 people were killed in neighboring Lorain.

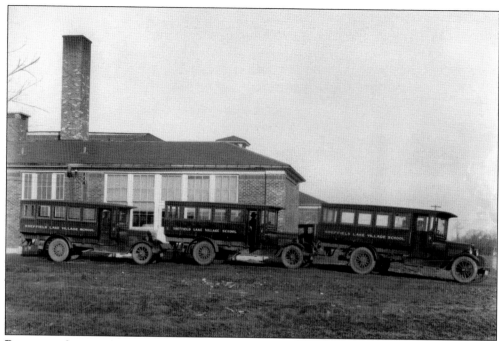

BROOKSIDE SCHOOL BUSES, 1925. This new centralized school served grades one through eight in Sheffield Lake Village. Three school buses provided transportation to students who lived more than a mile from the school. Located at the intersection of Colorado Avenue and Harris Road, it was originally constructed with six classrooms and a gymnasium. Reconstruction after the tornado added three classrooms and facilities for manual training and domestic science.

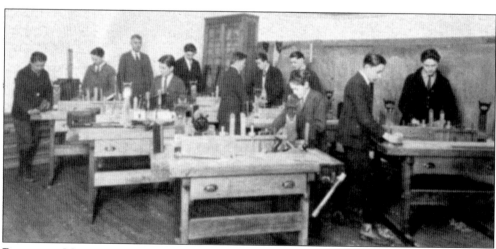

BROOKSIDE MANUAL TRAINING CLASS, 1925. Later known as industrial arts, or simply "shop class," this training was instituted for male students when Brookside reopened in 1924 after the tornado of June 28. In the early years, it was mainly a woodworking experience supplemented with mechanical drawing. A survey by the county school superintendent, E. C. Seale, indicated that adequate equipment was provided and that much of the work was of a caliber to be proud.

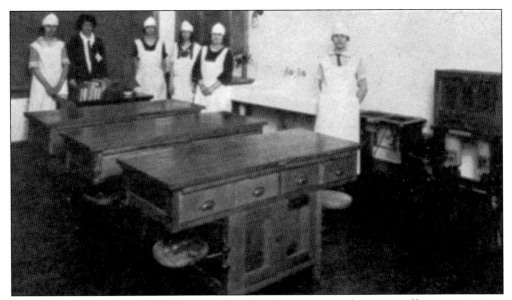

BROOKSIDE DOMESTIC SCIENCE CLASS, 1925. This class was an early version of home economics, with training mainly directed at cooking and sewing. The parent-teachers association cooperated with the domestic science classes by furnishing equipment and cooking supplies and at times assisting with the instruction. As an incentive, prizes were awarded by the Lorain County Fair Association for the most excellent sewing project in the class.

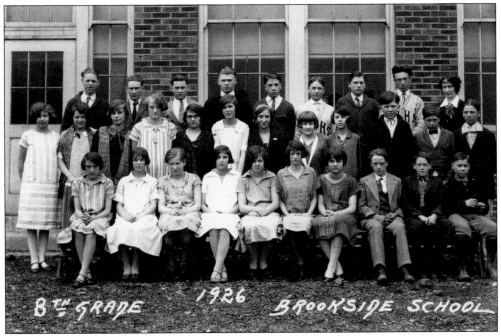

BROOKSIDE SCHOOL EIGHTH GRADE, 1926. Brookside School had 31 students in the eighth grade in 1926. Because Brookside only offered education through the eighth grade, these students constituted the graduating class that year. Starting in 1929, all 12 grades were offered in the same building. A new Brookside High School was constructed in 1968, and the old school building became Sheffield Middle School.

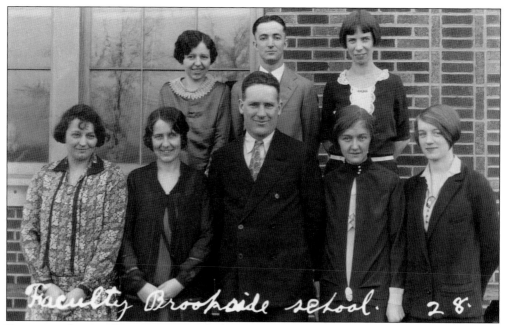

BROOKSIDE SCHOOL FACULTY, 1928. The faculty in 1928 consisted of eight teachers. James A. McConihe, first row center, served as principal, taught mathematics, and coached the boys' basketball and baseball teams. Initially Brookside School only offered classes through the eighth grade. In 1929, Brookside was accredited by the Ohio Board of Education as a Class A high school and graduated its first senior class the next year.

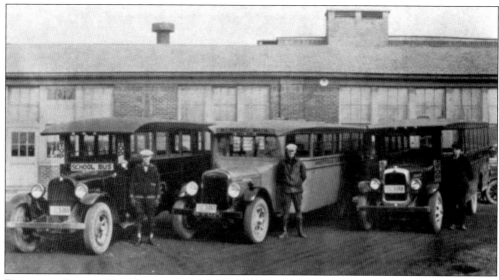

BROOKSIDE SCHOOL BUS DRIVERS, 1930. By 1930, Brookside had become a high school with 12 grades of instruction. Bus drivers are, from left to right, Wilbur Osborne, Roy Clites, and Earle Johnson. Wilbur and Roy drove lakeshore routes, while Earle handled the ridge. In the aftermath of a bus/interurban trolley collision in 1924 that killed four students, Brookside instituted student bus guards. The 1930 guards were Wm. Reeder, J. Owen, and H. Carrick.

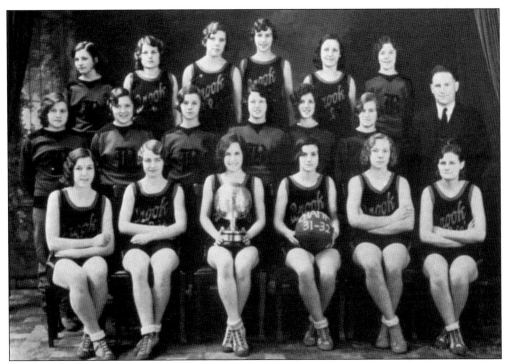

THE 1931–1932 GIRLS CHAMPIONSHIP BASKETBALL TEAM. Girls' basketball was a very popular sport in the 1930s. The 1931–1932 team brought Brookside High School its first girls' championship, winning all of its games. Coach James McConihe stated, "The success of the team was due entirely to the wonderful spirit shown by every member of the squad. The aim of the team was to fight hard and play clean and fair."

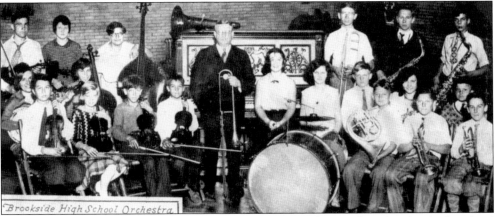

BROOKSIDE SCHOOL ORCHESTRA, 1932. Before Brookside had a marching band, it had a school orchestra that was started in 1930 under the direction of Gerald Franks. The 1932 orchestra pictured here had 20 student members under the direction of Mr. M. Osbun. Brookside's orchestra performed for 15 years before being replaced by a marching band. In 1946, the first marching band was organized under the direction of Karl Kolinski.

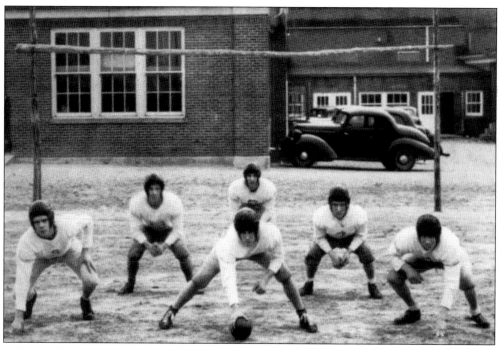

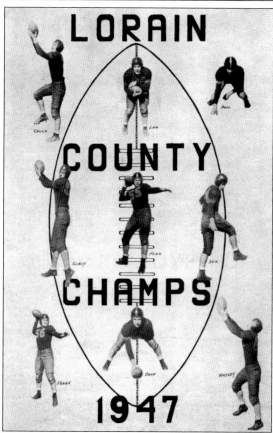

1944 FOOTBALL TEAM. In the 1940s and 1950s, Brookside High School played six-man football in a league with Lorain County schools. This 1944 team marked the start of a 25-game winning streak that extended over five seasons. Members of the first team are, from left to right, (first row) linemen Elmer Urig, Richard Rartunek, and Sam Radyk; (second row) backfielders John Jurasin, Joe Moldovan, and Lawrence Gallagher.

1947 CHAMPIONSHIP FOOTBALL TEAM. Starting the 1947 football season, Brookside had an unbeaten record of 13 games and two league championships. The pressure was on for another successful season. The team rallied by winning all seven games, compiling 366 points against opponents' 50. This enviable record, the best in Ohio, earned the team the title of "Mythical State Champs."

BROOKSIDE SCHOOLYARD, 1948. The schoolyard was a gathering place for students, faculty, and staff in the in the 1940s. In this 1948 photograph, Robert Carver (left), industrial arts teacher and assistant coach; Mr. Smith (center), custodian; and Earle Johnson, bus no. 2 driver for the ridge route, take a break before loading the school bus after classes.

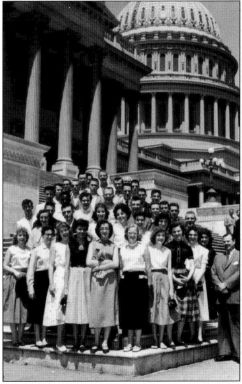

A 1957 CLASS TRIP TO WASHINGTON. In 1946, Brookside established a bank account for this class, and student treasurers were elected. For 12 years, class members sold magazines, had bake sales, and sponsored dances to earn money to add to the account. The goal was to finance a trip to Washington, D.C., and Gettysburg National Military Park. The class was exceedingly successful and is pictured here at the Capitol with Ohio congressman A. D. Baumhart.

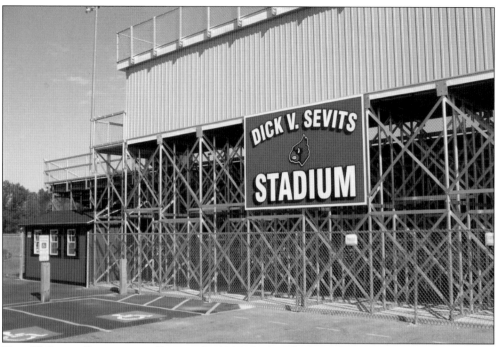

DICK V. SEVITS STADIUM AND PARADE. In 2007, the Brookside High School football stadium was renovated and renamed in honor of coach Dick V. Sevits. He served on the faculty of Brookside High School from 1951 to 1984, teaching industrial arts, physical education, drafting, ceramics, and driver education, as well as coaching basketball, football, and baseball. In January 1989, coach Sevits was the charter inductee to the Brookside High School Hall of Fame. The year 2007 was also the 50th anniversary of the transition from six-man to 11-man football at Brookside. To celebrate these events, a parade was held at the stadium prior to the October 5 football game. Sevits was driven around the field in a 1977 Mercedes 450SL, while members of the 1957 football team paraded behind.

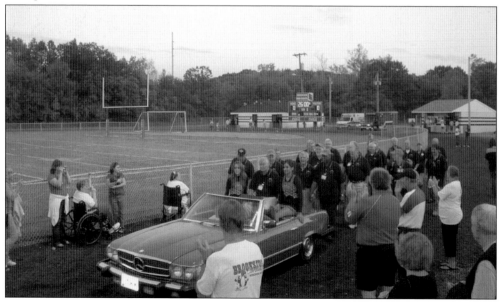

Five

BUSINESS AND INDUSTRY

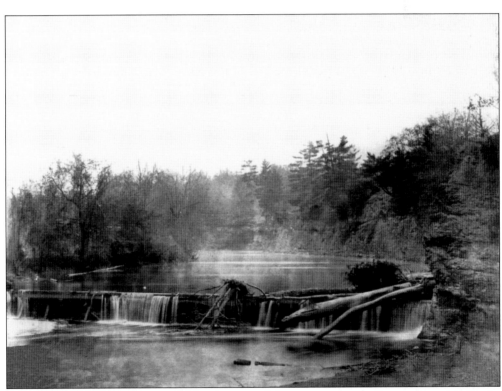

DAY'S DAM ON BLACK RIVER, 1890s. As part of the contract to purchase a township in the Connecticut Western Reserve, proprietors were required to build a sawmill and gristmill for the use of settlers. This dam was built in 1818 by Capt. John Day and Capt. Jabez Burrell to provide a constant head of water to power undershot waterwheels at their mills located a short distance downstream.

DAY'S MILLS RACEWAY. When Capt. John Day planned the dam and mills in 1818, he determined that a raceway would be needed to carry water from the pond formed by the dam. Because of the narrowness of the valley between the dam and the mills, a tunnel-like notch had to be excavated in the shale bluff. The notch shown here has since been filled by erosion of the cliff face.

DAY'S GRISTMILLS AND SAWMILLS. This photograph, taken long after the mills ceased to operate, shows their remains. The gristmill was located on the river's west side and the sawmill on the east. Thinking it hindered fish from migrating upstream, Elyria fishermen dynamited the old dam about 1885. An account from that period notes, "Elyria fishing was not much improved."

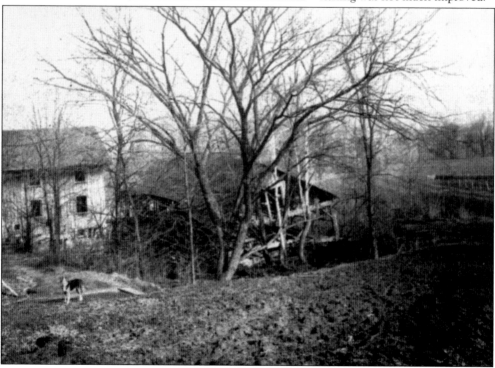

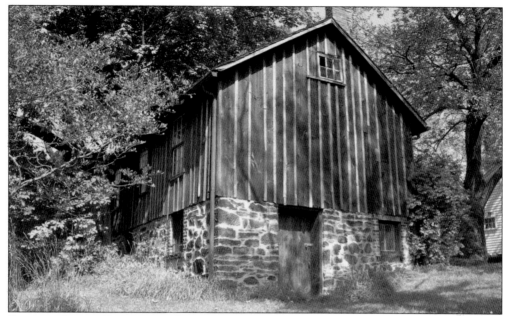

BURRELL CHEESE FACTORY. In the 1870s, the Burrell family constructed this cheese house on their East River Road homestead and operated a cheese factory there until the early 1900s. The cheese-making process included pouring milk into large cheese vats, heating it to 95 degrees Fahrenheit, and precipitating the solids in the milk. The solids, known as curds, were partially dried and then pressed into blocks of cheese.

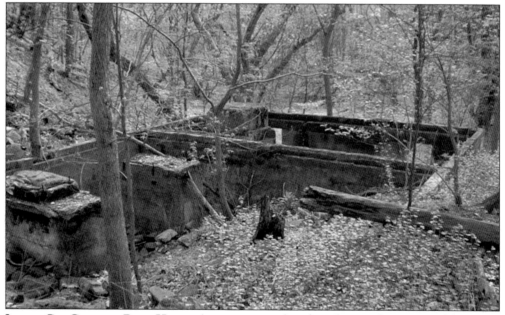

LOGAN GAS COMPANY PUMP HOUSE. An experimental gas liquefaction plant operated from 1916 to the mid-1930s on Ford Road. The plant produced high-octane gasoline from local natural gas wells. The plant's chief engineer, Charles Crosby, lived nearby in the Reynolds-Hammer house on Detroit Road. Large pumps drew water from the Black River to cool the plant's compressors. This foundation is all that is left of the once thriving facility.

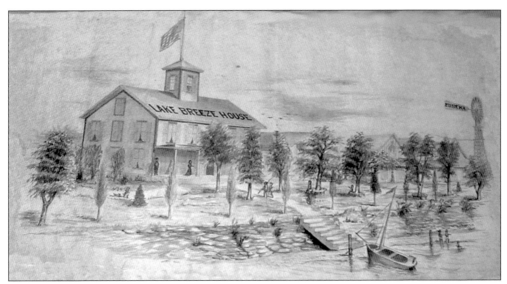

LAKE BREEZE HOUSE, LAKESIDE VIEW. In the 1860s, this Lake Erie resort was operated by Jay Terrell. An avid fossil collector, in 1867 he discovered armor plates of an ancient fish in the lake's shale cliffs. The fish lived 375 million years ago in the Devonian Sea that covered Ohio. Terrell presented the specimens to the Ohio Geological Survey. In 1874, Dr. John Newberry named the fish in the discoverer's honor, *Dunkelosteus terrelli.*

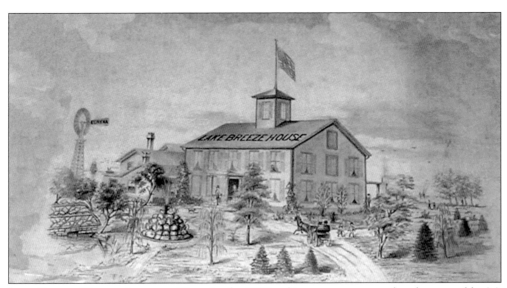

LAKE BREEZE HOUSE, ROADSIDE VIEW. In the 1880s, this resort was owned and operated by M. J. Lampman. Surrounded by shade trees, the buildings stood 28 feet above the water and 75 feet back from the shore. There was easy access to a sand beach, where rowboats were moored for guests to use. Dining tables were supplied with fresh milk, cream butter, fruits, and vegetables. Spacious box stalls afforded accommodation for horses.

HULETT UNLOADERS.
Located at the National
Tube Company dock in the
mid-1900s, the arm of the
unloader was lowered into
the hold of a Great Lakes
freighter by an operator who
rode in a tiny cab just above
a clamshell bucket. Iron
ore, mined in Minnesota,
was loaded onto freighters
for transportation through
the Sault Saint Marie
locks and down the upper
Great Lakes to the mills.

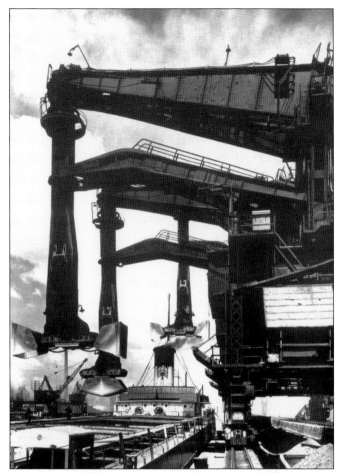

**NATIONAL TUBE COMPANY,
AERIAL VIEW.** These steel
mills were built on the west
bank of the Black River in
1894 as the Johnson Steel
Company. At that time, the
City of Lorain annexed a
large portion of northwestern
Sheffield Township on which
Tom Johnson built these
mills. His Sheffield Land
Company constructed houses
for thousands of workers
on land that came to be
known as South Lorain.

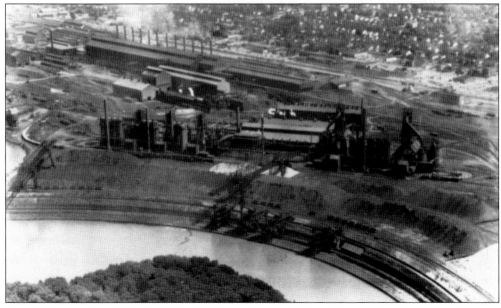

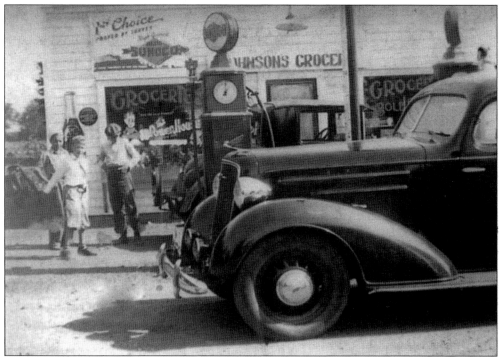

JOHNSON'S GROCERY STORE, 1930s. Earle and Florence Johnson operated a grocery store and filling station on Detroit Road for nearly 30 years starting in the mid-1930s. At the time, Johnson's was the only grocery store in Sheffield Village. Initially, fuel was supplied by Sunoco, and in later years the store carried Fleet Wing gasoline. The boys are, from left to right, Mick Radyk, Bill Johnson, and Lee Townsend.

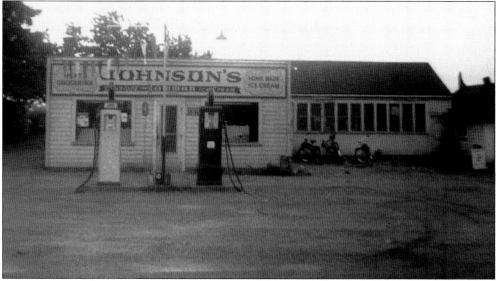

JOHNSON'S STORE, 1950s. The Johnsons added an ice cream parlor in the 1950s and served light meals. In the summer, they operated a drive-up window for ice cream cones. In addition to running the store, Earle Johnson served for many years as a Brookside School bus driver during the period when all 12 grades were located in a single building.

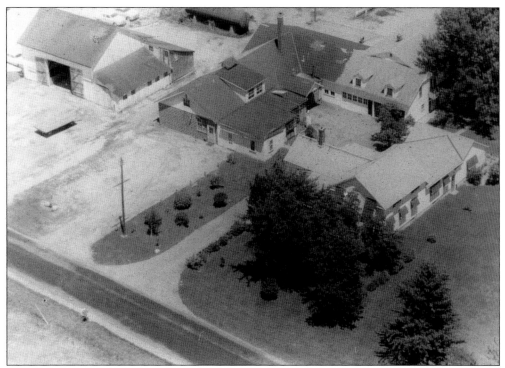

MACKERT'S DAIRY, AERIAL VIEW. Ed Mackert started his dairy business on Abbe Road in the 1930s. This 1952 aerial photograph shows the operation during its period of peak production. The components of the dairy, from left to right, included a large cow barn, the dairy building with a pasteurizer and bottle carton plant, and two residences for family members.

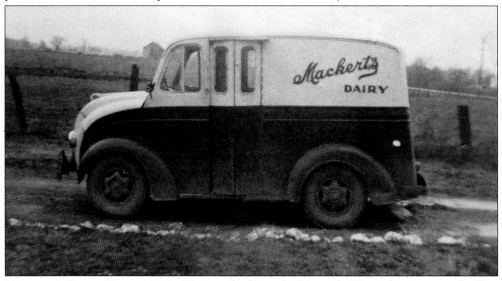

MACKERT'S DAIRY TRUCK, 1950. This truck, driven by Kenneth Wisnieski, was one of a fleet of 20 operated by Mackert's Dairy. Drivers/salesmen operated regular routes in Sheffield, Avon, Bay Village, Elyria, and Lorain, as well as wholesale deliveries to schools and retail stores such as Johnson's Grocery on Detroit Road. Ed Mackert was ahead of his time by experimenting with propane as a fuel for his delivery trucks.

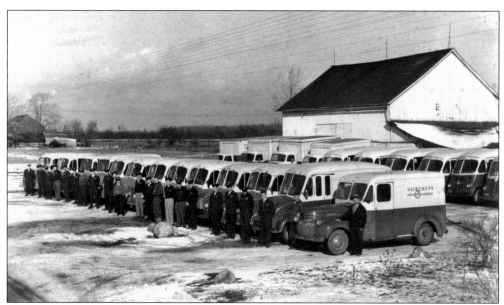

DAIRYMENS MILK COMPANY FLEET. In 1954, Dairymens Milk Company, founded in 1921 in Cleveland, Ohio, purchased Mackert's Dairy as a substation. This photograph, taken shortly after the purchase, shows the fleet of some 25 delivery trucks. Ed Mackert, standing at the far right, stayed on for a year as manager during the transition period.

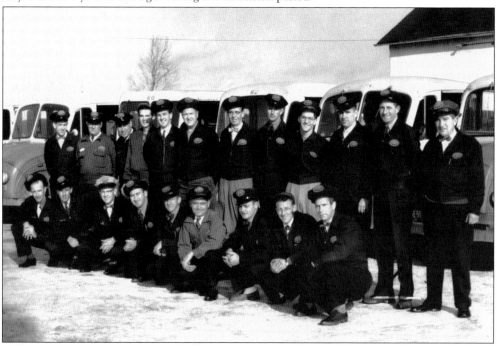

DAIRYMENS MILK COMPANY DRIVERS. Dairymens retained all of Mackert's drivers and fleet of trucks, only repainting the name on the sides of the trucks. Dairymens operated the substation for 15 years, constructing a new brick building for processing raw milk. With increased residential and commercial development on former dairy farmland, the supply of raw milk declined, and the Sheffield substation was closed in 1969.

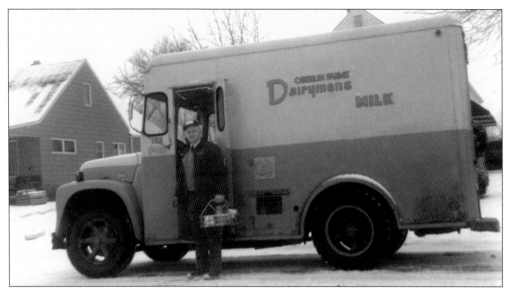

DAIRYMENS MILK TRUCK. This 1976 photograph shows Paul Smith delivering Dairymens milk in Sheffield Lake. Smith, a resident of Sumner Street in Sheffield, started working for Mackert's Dairy, then transferred to Dairymens, spending a total of 35 years in the dairy industry. Paul was serving as substation manager when the facility was closed, and he was transferred to the main plant in Cleveland.

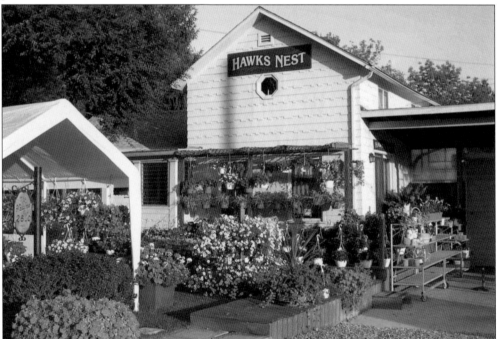

HAWKS NEST GREENHOUSE. This colorful garden center is located on North Ridge in Sheffield Township. Grain and hay fields and pastures dominated the landscape for over 100 years. As urban areas developed, row crops and truck farms became more profitable. After World War II, the sandy soil of North Ridge proved ideal for growing tomatoes in greenhouses. Most of the remaining greenhouses have been converted to raise flowers and ornamental shrubs.

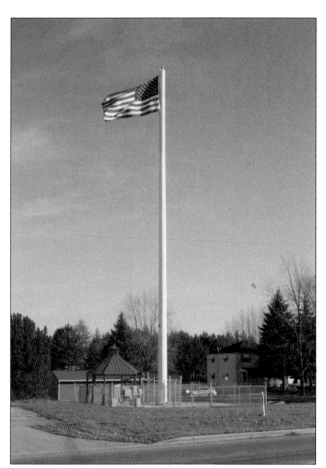

T-Mobile Cellular Antenna Tower. Cell towers do not have to be ugly. This one, located at the intersection of Detroit and Gulf Roads, is an example of what can be done to enhance their appearances. The tower, 120 feet tall, is graced by an illuminated American flag. The antenna itself is completely mounted inside the shaft at 117 feet above the ground.

The Lucky Find. This secondhand and remainder store was located in the Reynolds-Hammer house at 4747 Detroit Road in the 1990s. In 2005, the building was remodeled by Elmer and Jeanette Scott and reopened as Ye Olde Village Kountry Store, specializing in Amish food and furniture. During the 1940s and 1950s, Herbert Langthorp, Sheffield Village fire chief from 1953 to 1957, and his family occupied this house.

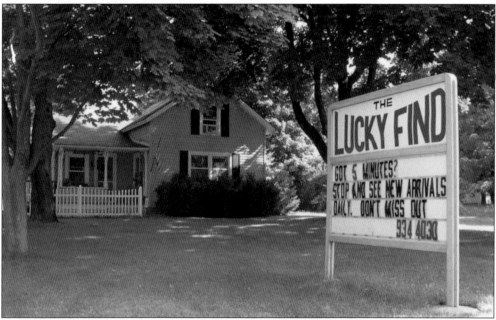

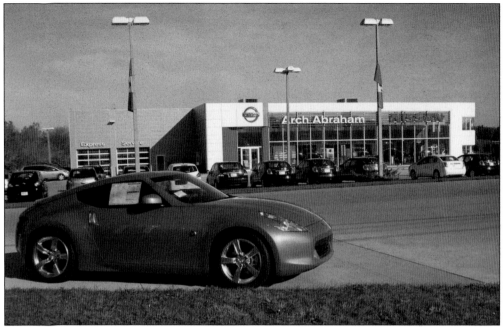

Nick Abraham Nissan. This automobile dealership is one of six that have been built on Detroit Road at the Interstate 90 interchange in the last two decades. This land was originally part of the Milton Garfield estate, passing to his son Daniel, then to Daniel's daughter Estella Taylor, and finally to the Laskin family before being sold to the Abrahams.

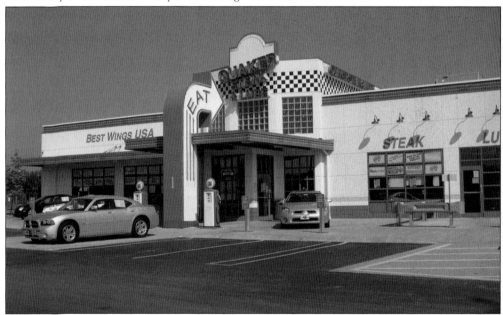

Quaker Steak and Lube. This retro 1950s bar and restaurant is located on Transportation Drive, adjacent to the Interstate 90 interchange at Detroit Road. Built in 2004, it caters to motorcycle and vintage automobile clientele, which has changed the peaceful character of the neighborhood. Live outdoor entertainment is featured in the summertime. The 254 Diner, a retro 1950s café, is located immediately to the west.

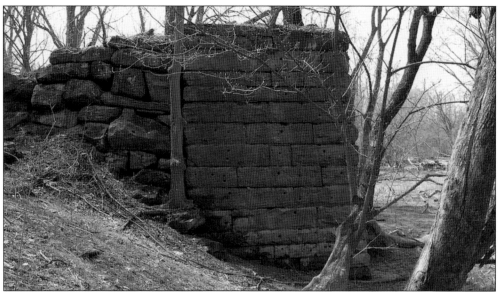

DAY'S DAM BRIDGE, SOUTH ABUTMENT. All that remains of the Day's Dam bridge is this sandstone block abutment on the south side of the river and the steep approach road on the north side. As with the Garfield Bridge, local farmers lobbied for a high-level bridge to transport their produce to markets on the opposite sides of the river; this was accomplished with construction of the Thirty-first Street Bridge in 1913.

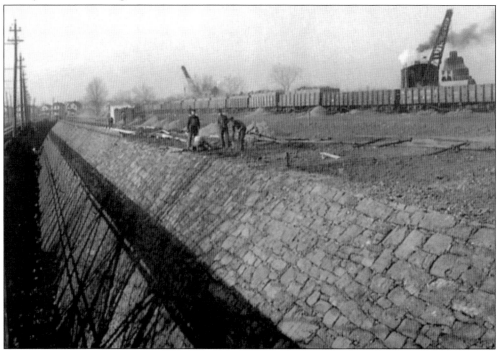

THIRTY-FIRST STREET BRIDGE CAUSEWAY. Unlike the Garfield Bridge of two decades later, which had a viaduct spanning the entire width of the valley, the length of the Thirty-first Street Bridge was shortened with the construction of an 800-foot-long causeway. This 1913 photograph shows the construction of the massive retention wall that was needed to stabilize the causeway.

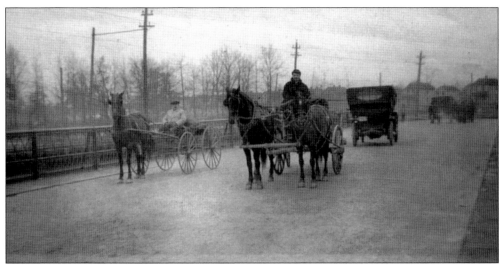

THIRTY-FIRST STREET BRIDGE OPENS. The high-level bridge over the Black River at Thirty-first Street was completed in 1913 by the Pittsburgh Bridge Company at a cost of $62,000. The 370-foot ravine was bridged with a series of graceful arches. The bridge roadway was paved with hexagonal wooden blocks, and creosoted planks were installed to form sidewalks.

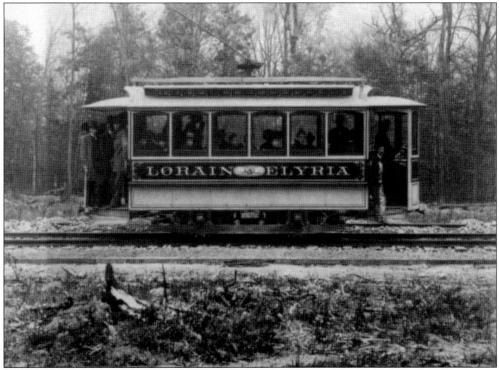

LORAIN-ELYRIA INTERURBAN TROLLEY. This trolley car started operating in 1894 between Lorain and Elyria on Tom Johnson's "Yellow Line" Electric Railway. The line was built to transport workers to his new steel mill in South Lorain. The trolley is shown here passing through the woods of Sheffield Township. The clasped hands painted on the side of the car represent on the joining of the two cities.

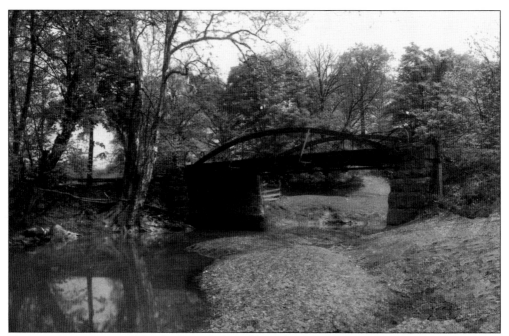

FRENCH CREEK BRIDGE. This bridge is believed have been located on Abbe Road (then named Bennett Road), a short distance south of St. Teresa Church. The iron-truss structure was mounted on heavy sandstone abutments and had a span of about 50 feet. This late-1800s structure has been replaced by three other bridges in the past 100 years.

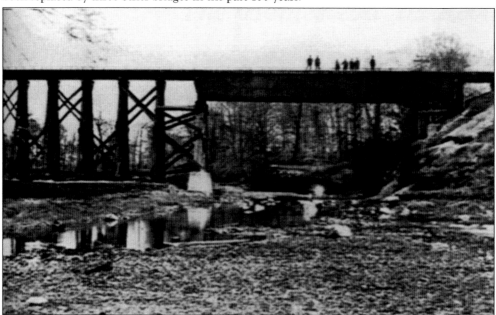

LAKE ERIE AND PITTSBURGH RAILROAD TRESTLE. This wooden trestle was built over French Creek in 1917 to service the Cromwell Steel Company on the Black River at Root Road. The railroad operated the line until the early 1920s when the need for steel collapsed after the end of World War I. The track was taken up in 1926. Only an old abutment remains near the French Creek Nature Center.

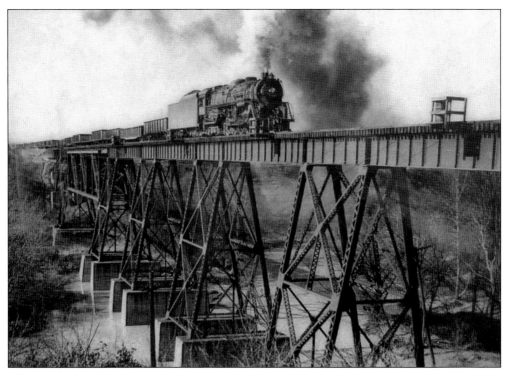

COAL-FIRED STEAM ENGINE, 1934. The Lorain and West Virginia Railway constructed this trestle over the Black River in 1906 to carry southern Ohio and West Virginia coal to the newly constructed steel mill a few miles downstream. The trestle and connecting rail line were abandoned in the 1960s, but the trestle still stands just north of the Garfield Bridge on Detroit Road.

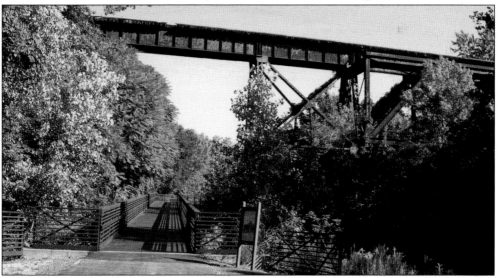

RAILROAD TRESTLE ABOVE BRIDGEWAY TRAIL. The abandoned Lorain and West Virginia Railway trestle over the Black River is one of the many interesting attractions along the Bridgeway Trail of Lorain County Metro Parks. Just downstream of the trestle, a 1,000-foot-long steel footbridge takes travelers 25 feet into the treetops along the trail. Informational panels identify noteworthy features alongside the 3-mile trail.

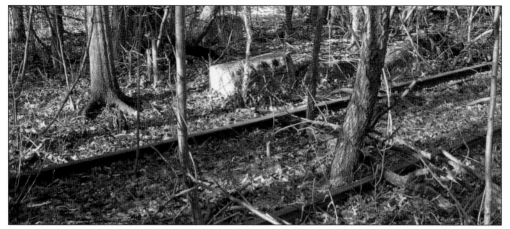

ABANDONED RAILROAD TRACKS. The Lorain and West Virginia Railway tracks have been abandoned for nearly 50 years. Trees have grown up around and even within the rails. This 2005 photograph shows foundation stones from a water tower that once supplied the steam engines a short distance east of the river trestle. Near this place, a roundhouse and Y track were built as a way to reverse engine direction.

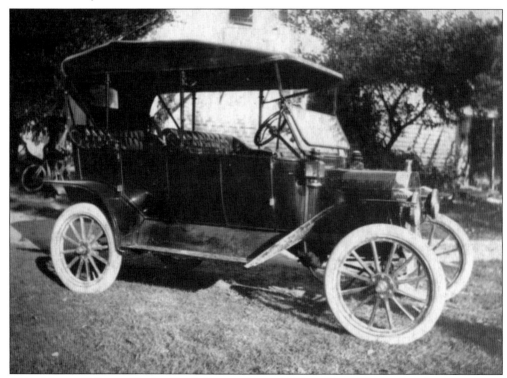

1910 MODEL T FORD. Shirley Garfield, grandson of Milton Garfield, the founding pioneer of Sheffield's North Ridge, was one of the first men to own an automobile in Sheffield. He farmed the Garfield family homestead land on North Ridge for many years and served as the sexton of historic Garfield Cemetery, located near his home on Detroit Road.

Seven

PUBLIC FACILITIES AND SERVICES

VILLAGE OF SHEFFIELD SEAL. This official seal of Sheffield Village, Ohio, was adopted by mayor John D. Hunter in January 2008. In designing the seal, Mayor Hunter recognized the history of Native Americans in the area and the contributions of early pioneers in carving Sheffield out of the wilderness of the Connecticut Western Reserve.

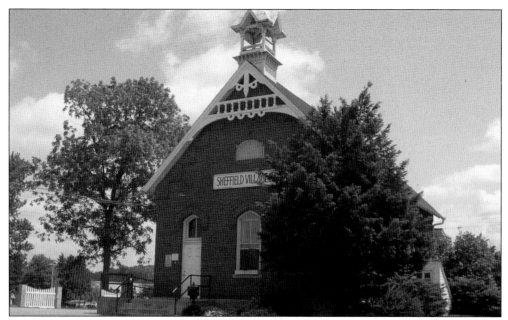

SHEFFIELD VILLAGE HALL. In 1935 for $500, the board of education of the Sheffield Lake School District transferred this North Ridge building, formerly district no. 1 schoolhouse, to the newly formed Village of Sheffield to be used as the village hall. This building continued to serve this purpose and to be used for other civil/social activities until a new municipal complex was constructed in 1999. Currently, offices for the clerk/treasurer and Garfield Cemetery are located here.

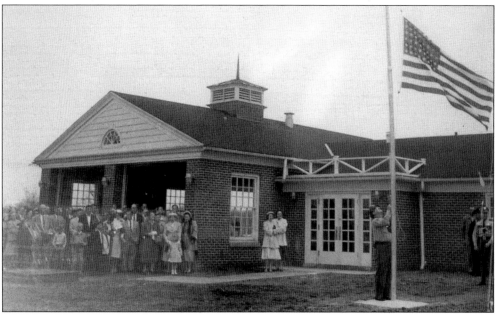

MUNICIPAL BUILDING DEDICATION, 1957. On April 28, 1957, the Village of Sheffield took a major step forward with the construction of this new building to house the fire and police departments. Located in the northwest corner of James Day Park, it was designed by architect Arnold Peterson and constructed under the direction of Joseph Finochi, of Root Road Construction Company, for $42,700.

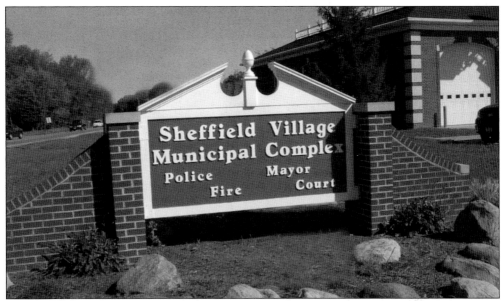

VILLAGE OF SHEFFIELD MUNICIPAL COMPLEX. Constructed in 1999, the Municipal Complex houses several departments of village government. The complex, located at the intersection of Colorado Avenue and East River Road, was constructed by enlarging the fire/police station built in 1957. The east wing of the structure consists of a spacious chamber for the village council that can seat over 100 people. The mayor's offices are located at the center. The west wing holds the fire and police departments. Other municipal buildings include the Sheffield Village Hall at 4820 Detroit Road, which houses offices for the clerk/treasurer and Garfield Cemetery, and the service department facility at 4480 Colorado Avenue.

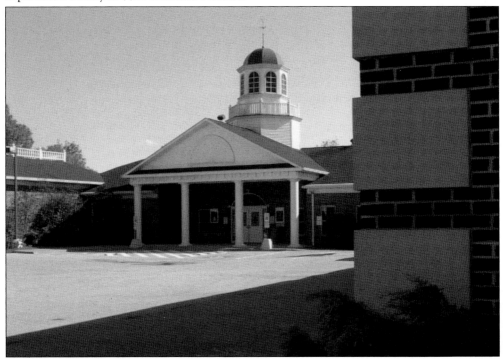

1946 Chevrolet/Bean Fire Truck. Sheffield Village needed new fire truck in 1941, but during World War II few were manufactured for domestic use. In 1946, the village council passed an ordinance to purchase a fire truck from John Bean Manufacturing Company of Lansing, Michigan, for $5,790. Here Leo Sheets, fire chief in 1966 and 1967, stands beside the historic fire truck that was donated to the Sheffield Village Historical Society in 2009.

Sheffield Village's Fire Trucks, 1957. In 1957, Sheffield Village purchased a new Howe fire truck for $11,300 and new hoses and other fire equipment for $3,700. At that time, the fire department had a chief, four other officers, and 16 volunteer firemen. In this photograph are, from left to right, a 1933 Ford truck, assistant chief Herb Langthorp, a 1946 Bean truck, chief Edward Herdendorf, and a 1957 Howe truck.

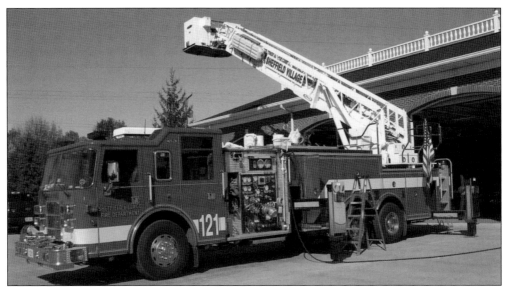

SHEFFIELD VILLAGE FIRE DEPARTMENT, 2008. Currently, the fire department is comprised of 23 firefighters and officers. In addition to being certified as firefighters by the State of Ohio, all are certified emergency medical technicians and paramedics. This tower-ladder fire truck is the pride of the department. Other firefighting equipment includes two pumper trucks, three medical transport ambulances, and two multipurpose utility vehicles.

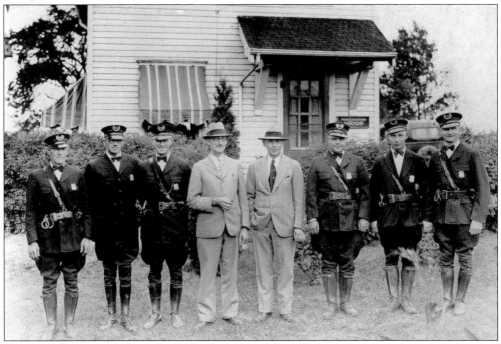

SHEFFIELD LAKE VILLAGE OFFICIALS, 1930. In this photograph are, from left to right, Deputy Marshals F. Young and Henry "Harry" Garfield Root, Marshal W. L. "Roy" Clites, clerk Frank Field, Mayor Fred Hosford, and Deputy Marshals A. Welter, A. Gilles, and W. Osborne. Deputy marshal L. Cheney was appointed shortly after this photograph was taken. During the Prohibition era, a fairly large law enforcement staff was necessary even for a small village of just 1,200 residents.

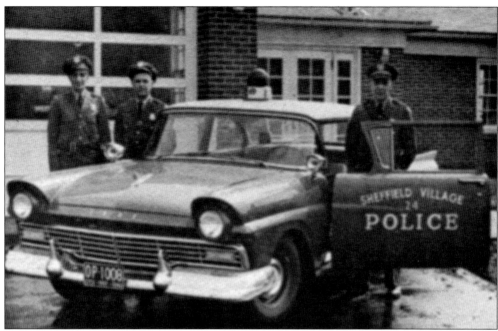

SHEFFIELD VILLAGE POLICE DEPARTMENT, 1957. The police department consisted of a chief and five part-time officers. Here, chief Fred Winter stands by the open door of a new Ford police cruiser outside the police office on Colorado Avenue. His deputies were James Garber, Mike Hanko, Alvin Schmitz, Joe Temkiewicz, and Steve Toth. Prior to 1957, the police used the village hall, where mayor's court was also held, as an office. Deputies Schmitz (left) and Temkiewicz are shown here.

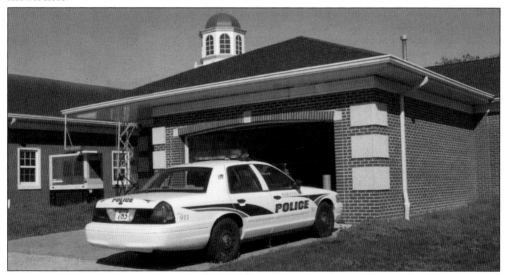

SHEFFIELD VILLAGE POLICE STATION, 2008. The police department has evolved from a small part-time department to one that now employs 16 full-time officers and dispatchers. Modern police cruisers like the one seen here continually patrol the village providing assistance and crime prevention. The department has a detective bureau certified by the Ohio Peace Officer Training Commission. In partnership with the board of education, the department employs a school resource officer.

SHEFFIELD VILLAGE'S FIRST ROAD GRADER. In the early days of Sheffield Village, before paved roads, this grader was used to smooth road surfaces throughout the village. The machine was a McCormick-Deering Warco one-man grader (Model H-P) fabricated in 1928 by the Riddell Company in Bucyrus, Ohio. Simon Kriebel was the village's first street commissioner and operator of the grader. By 1958, it was considered obsolete and ended up at the farm of Fred "Fritz" Caley on East River Road (above). In 2003, his son-in-law Frank Root Jr. of Avon, Ohio, decided to have the grader restored to its original condition (below). The grader had four steering wheels—one to operate a scarifier used to break up the ground, two for controlling the depth and position of the scraper blade, and a center wheel for steering.

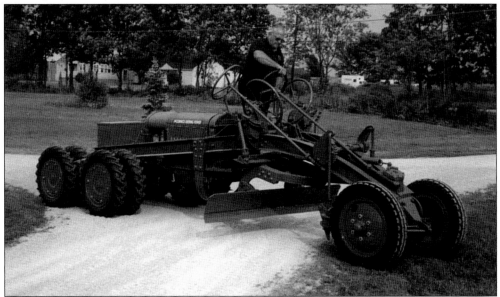

SHEFFIELD SERVICE BUILDING SIGN. In the winter of 1995, Leo Sheets, administrator of the service department, decided that the relatively new service building at 4480 Colorado Avenue needed an identifying sign. He and his staff fabricated this 30-foot-long sign out of 2-inch thick foam board covered with stucco-like cement. The staff members shown here working on the sign are Bill Sheets (left), Rudy Ackerman (center), and John Ackerman.

SHEFFIELD VILLAGE SERVICE DEPARTMENT. This unit of the village administration actually consists of several departments—water, sewer, street, stormwater, parks, cemetery, and building. All of these are taken care of by nine village employees. They service waterlines to 1,800 residences and commercial establishments as well as 530 fire hydrants. The service staff is also responsible for maintaining 80 miles of roadways. Here the service department's chipper is providing free service to residents.

SHEFFIELD'S PIONEER CEMETERY.
Located on East River Road, not far from the Jabez Burrell homestead, a small cemetery was established in 1825. Surrounded by a wrought iron fence, there are only 13 burials, but individuals resting here represent the founding families of the village. The first burial was 26-year-old Rhoda Marie Day, the second daughter of Sheffield founders Capt. John and Lydia (Austin) Day. With the exception of one person, Mary Betts, all of those interred here are members of the Day and Root families. Most notably, Capt. John and Lydia Day (gravestones pictured at right) and Henry and Mary (Day) Root. Later members of these founding families are buried in Garfield Cemetery on North Ridge.

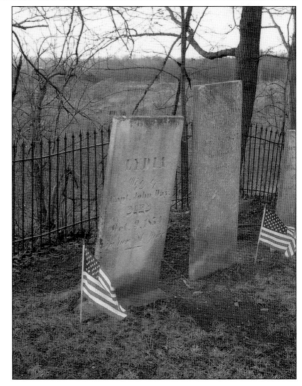

GARFIELD CEMETERY MEMORIAL GRAVESTONES. Garfield Cemetery on North Ridge, adjacent to the Sheffield Village Hall, was established in 1851 when Milton and Tempe Garfield sold 1.2 acres of their farmland to Sheffield Township for the purpose of creating a cemetery. However, this land had informally been used as a graveyard for many years, with some 56 burials having taken place here before 1851. Once established, family plots were assigned to various pioneer families, and a tax was collected from these families to finance the maintenance of the cemetery. Sheffield founders Jabez and Mary Burrell died in the early 1830s and were likely buried near their French Creek homestead. These memorial stones were later placed in Garfield Cemetery.

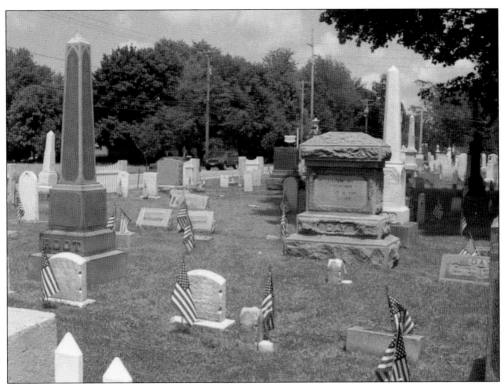

GARFIELD CEMETERY MONUMENTS.
Garfield Cemetery contains a total of 1,770 grave sites, of which about 950 have been utilized for burials. At least 60 of the decedents have seen military service, representing all major conflicts since the Revolutionary War. Markers at their graves recognize their service, including 23 Grand Army of the Republic bronze markers for Civil War veterans. There are over 700 stone monuments. Marble and granite are the most common types of stone used for gravestones, accounting for 43 percent and 41 percent, respectively. Many of the older monuments were made of white and gray marble, but most of these have suffered erosion to the point where inscriptions are difficult to read. The tree-shaped monument for Lysander and Mary Parks (right) is unique in that is the only one carved from fossiliferous limestone, exhibiting abundant crinoid stalks.

SHEFFIELD HISTORY CENTER. The Sheffield Village Historical Society is headquartered in the former Root-McAllister house at 4944 Detroit Road. Now known as the Sheffield History Center, the building contains the documents, photographs, artifacts, and other materials relevant to the history of Sheffield and the surrounding area. The collections are cataloged on a computerized database that includes a digital image of each item that has been accessioned. One of the prized articles in the collection is this original painting of the Berkshire Mountains near Sheffield, Massachusetts. The painting below was done by William Watson and given to the society before his untimely death in 2007. It depicts the New England homeland of the original pioneers who settled Sheffield, Ohio, in 1815.

Eight

ARCHAEOLOGY
AND NATURE

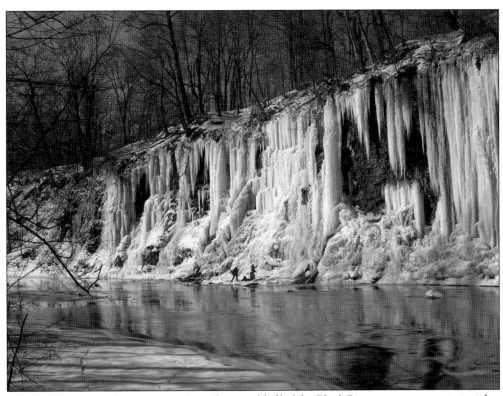

ICE CLIFFS. Fort Lot Springs issues from the west bluff of the Black River to create massive icicles. Groundwater seeping into the sandy soil at the top of the bluff encounters layers of impervious black shale, then falls to the valley floor along the face of the bluff. A hard freeze following a winter thaw produces this spectacular display. Fort Lot was a bluff-top fortified village occupied by prehistoric Native Americans 600 years ago.

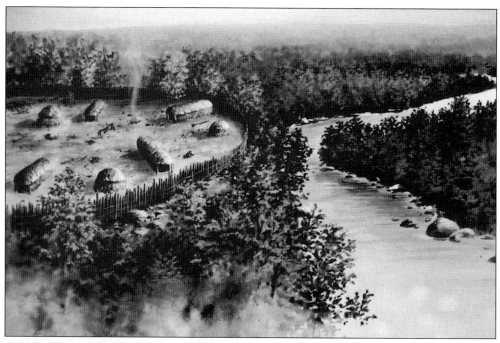

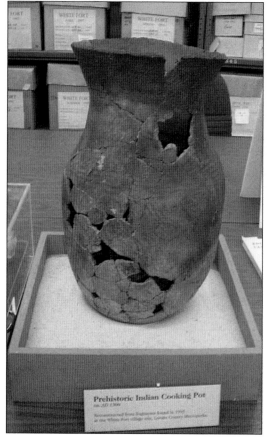

Prehistoric Indian Cooking Pot
ca. AD 1300
Reconstructed from fragments found in 1995
at the White Fort village site, Lorain County Metroparks.

PREHISTORIC FORT LOT. This drawing of Fort Lot (also known as "White Fort") is based on excavations by the Cleveland Museum of Natural History along the Black River bluff south of Garfield Bridge. A major prehistoric occupation was revealed at the site, consisting of a stockaded village settlement that flourished in the 14th century. The settlement was affiliated with the Sandusky Tradition of Late Woodland people who inhabited northwestern Ohio at that time.

WHITE FORT ARTIFACTS. This ceramic vessel was excavated from the White Fort site on the Black River by Dr. Brian Redmond of the Cleveland Museum of Natural History in 1995. The vessel, classified as Mixter Dentate style, was made by prehistoric Native Americans some 600 years ago. Other artifacts included stone projectile points, the majority being triangular flint of the Madison type that were most likely true arrow tips.

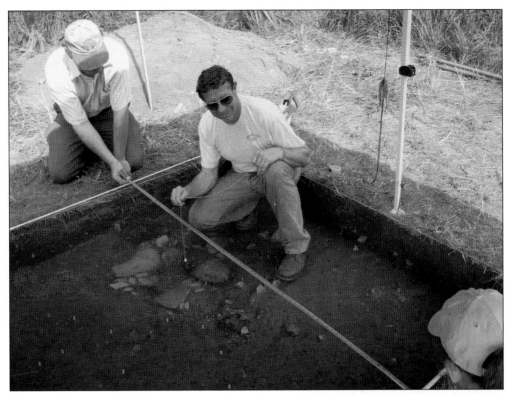

BURRELL ORCHARD SITE EXCAVATION.
This archaeological site is on
a promontory overlooking the
confluence of French and Sugar
Creeks just before the former
flows into the Black River. Eddie
Herdendorf, a docent with the
Cleveland Museum of Natural History,
maps the location of fire-cracked
rock and a siltstone platform in an
excavation unit that proved to be
features of an Archaic Indian village
occupied over 4,500 years ago.

**BURRELL ORCHARD SITE CULTURAL
DEPOSITS.** Dr. Brian Redmond takes
measurements of midden strata (layers
of trash material) in 2008 at this
Archaic Indian village site: A—plow
zone, B—midden layer with fire-
cracked rock, C—subsurface clay
layer purposefully placed on a fire
pit, D–fire pit with charcoal deposits,
and E—post–mold/decayed wood
traces indicative of a post placed in
the ground thousands of years ago.

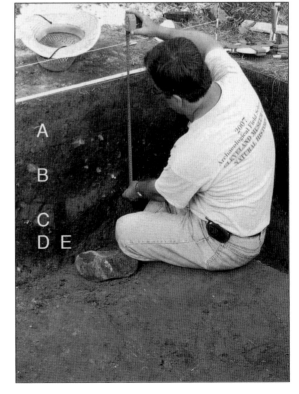

BURRELL FORT EARTHWORKS. Burrell Fort archaeological site is located on a promontory above French and Sugar Creeks, within the French Creek Reservation of Lorain County Metro Parks. This view shows the mound (left) and the trench (right) built by Woodland Indians as a fortification for their village over a thousand years ago. A wooden stockade once stood on top of the mound to protect the village from invaders.

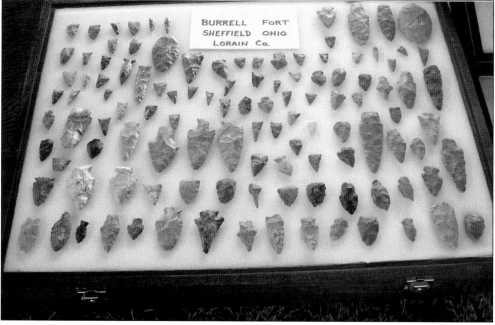

BURRELL FORT ARTIFACTS. This collection of artifacts contains lithic (stone) projectile points and flint tools used by Woodland Indians at their village site. The larger points were likely attached to throwing spears, while the smaller points were used as arrow tips. Shards of pottery and fire-cracked rock are still commonly found at this site.

118

PREHISTORIC PROJECTILE POINTS.
These Native American artifacts were
found as surface collections by Dennis
Bryden on his family's North Ridge
farm in the 1960s. They represent the
most ancient Native American cultures
to inhabit Sheffield. The lanceolate
point (left) was made by Paleo-Indians
some 9,000 years ago, and the corner-
notched point was fashioned by
Archaic Indians about 5,000 years ago.

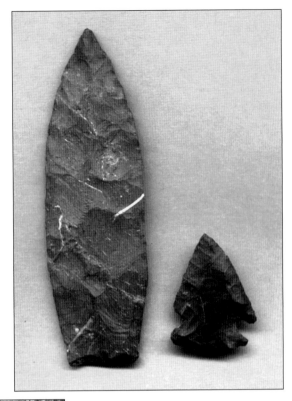

SHALE CLIFF WATERFALL. Several
hanging waterfalls of this type are
found along the high banks of the
Black River. Rainwater percolates
into the sandy soil of North Ridge
and drains to the river by way of these
falls. Floodwaters of the Black River
have cut its valley deeper than the
small streams that feed the waterfall,
leaving their brink high on the bluffs.

119

ANCIENT BEACH DEPOSITS. About 14,500 to 12,500 years ago, glacial lakes covered most of what is now Sheffield, and sandy beaches were formed across the southern limits of the village. The most prominent of these ancient beaches, North Ridge, was a main travel way for Native Americans and pioneers. Geologists have named the two bodies of water that formed this ridge Lakes Warren and Wayne. These lakes were 105 and 85 feet, respectively, above modern Lake Erie.

GLACIAL BOULDER. As continental glaciers pushed down from the Canadian Shield, they dislodged slabs of ancient granite. The slabs became rounded at the base of the glaciers, and many were eventually deposited in Sheffield. This 4-foot diameter granite boulder was left behind in the Black River valley as the glaciers melted. Such rounded boulders and smaller cobble-sized rocks, deposited far from their place of origin, are known as glacial erratics.

BLACK RIVER CLIFFS. This view of the Black River gorge to the north of Garfield Bridge shows the massive layers of black shale that form the cliff. These shale beds, known as the Ohio Shale formation, were deposited as mud layers in an ancient saltwater sea that covered Ohio during the Devonian Period, 375 million years ago. Over time, these muds became compressed into a sedimentary rock formation 600 feet thick.

EXTINCT PLACODERM FISH. This fossil fish (*Dunkelosteus terrelli*) lived in the Devonian Sea 375 million years ago. Jay Terrell was the first to find its fossils in shale beds at Lake Erie. Later Sheffield native Peter Bungart (shown at right), paleontologist at the Cleveland Museum of Natural History, was able to reconstruct the armored head shield of this 20-foot-long fish from flat specimens found in the shale beds. (Courtesy of Cleveland Museum of Natural History.)

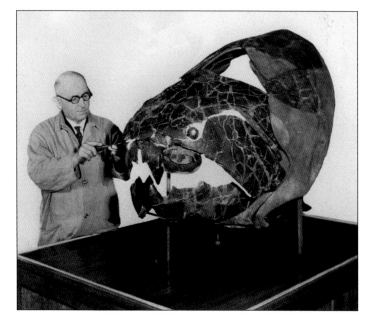

BLACK RIVER RAPIDS. This view of the rapids in the Black River upstream from the Thirty-first Street Bridge demonstrates the erosive power of the river in cutting a valley in the ancient shale beds. The Black River valley, having been excavated in the past 12,000 years since the last glacier melted to the north, is relatively young. This portion of the river is where Day's Dam was once located.

SILTSTONE LEDGE ON FRENCH CREEK. At places along French Creek and the Black River, the thin layers of the shale bed have been geologically cemented into siltstone layers that create what local geologists call a "natural sidewalk" along the streams. Archaeological excavations at a nearby Archaic Indian village indicate the inhabitants may have used these rock layers to form floor-like platforms in their dwellings.

ESCHTRUTH SANDSTONE QUARRY. This quarry was located in Vincent, a community in southern Sheffield Township. The rock here is somewhat younger than the Ohio Shale and was formed as erosion of the rising Appalachian Mountains carried sandy deposits to the Devonian Sea. Known as the Berea Sandstone formation, this quarry yielded stone used for foundations and door stoops for early homes on North Ridge.

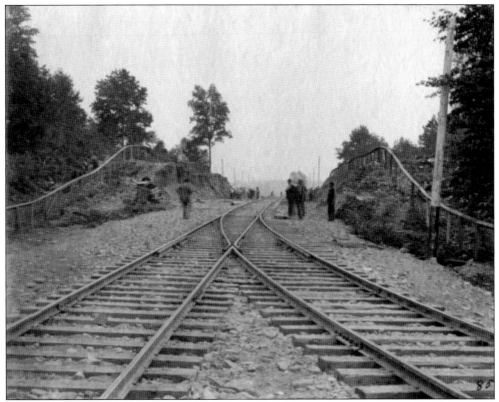

ESCHTRUTH QUARRY RAILROAD SIDING. As the demand for sandstone foundation material increased during the construction of the Johnson Steel Company and associated housing for the mill workers in the late 1890s, a railroad siding was built to connect the quarry with the main track running between South Lorain and Elyria.

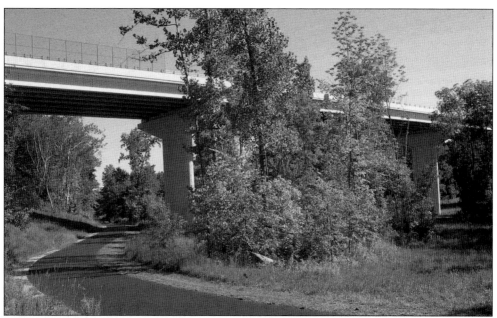

BRIDGEWAY TRAIL. This 4-mile trail runs the entire length of the Lorain County Metro Parks's Black River Reservation. The 12-foot-wide asphalt surface is suitable for hikers, bicyclists, rollerbladers, and users of other nonmotorized modes of transportation. The southern terminus of the trail is at High Meadows picnic area, passing under Garfield Bridge (pictured above) and ending at Day's Dam picnic area near the Thirty-first Street Bridge.

COTTONWOOD AT DAY'S DAM. This giant cottonwood tree (*Populus deltoides*) stands on the Black River floodplain. Pioneer accounts of other giant trees in the valley include one of a black walnut (*Juglans nigra*), thought to be Ohio's biggest. Once cut and trimmed in the late 1880s, it was 40 feet long and 6 feet in diameter. Sumner Burrell Day floated the log down the Black River and shipped it by train to the East Coast.

SLEDDING ON GASHOUSE HILL. When the Logan Gas Company was constructed on Ford Road in 1916, the road leading down the Black River bluff to the bridge became known as "Gashouse Hill." Long after the plant closed and a high-level aqueduct was constructed in the 1930s, Gashouse Hill remained a popular place for winter sledding. These boys, Donnie Hammer (left) and Jack Root, are on their way to the coasting hill in 1953.

WINTER ON NORTH RIDGE. Winter in Sheffield Village can be a beautiful time of year. This view of a snow-capped gazebo at the Milton Garfield farmhouse on North Ridge is an example of nature at its best. Typically the village experiences about 50 inches of snowfall each winter, with January being the heaviest month.

BIBLIOGRAPHY

Austin, Eleanor D. "The Pioneer Women of Sheffield," in *Memorial to the Pioneer Women of the Western Reserve. Part 1.* Wickham, Gertrude Van Rensselaer, ed. Cleveland, OH: The Women's Department of the Cleveland Centennial Commission, 1896.

Bins, J. C., Tempe Garfield Burrell, Edith Austin Cudebach, Charles Crehore, and May Day, eds. *History of the Day-Austin-Root August Reunions and Genealogy of the Day-Austin-Root Families 1636–1930.* Sheffield Lake Village, OH: Day-Austin-Root Reunion Committee, 1930.

Burrell, Doris, ed. *Sheffield.* Elyria, OH: Lorain County Metropolitan Parks, 1971.

Day, Norman. *A History of the Settlement of Sheffield and the Pioneers, and a Brief Address Prepared for a Pioneer Celebration of the Fiftieth Anniversary, on the Thirteenth Day of November, A.D., 1865.* Elyria, OH: The Democrat Office, 1876.

Gillotti, Daniel, and Cynthia Conrad. *St. Teresa of Avila Catholic Church—Sheffield, Ohio 1845–1995.* Sheffield Village, OH: St. Teresa Catholic Church Sesquicentennial Celebration Committee, 1995.

Herdendorf, Charles E. *Natural Vegetation of Sheffield, Ohio and the Factors Contributing to its Development.* Sheffield Village, OH: Sheffield Village Historical Society, 2009.

———. *Guide to the North Ridge Scenic Byway, Lorain County, Ohio.* Sheffield Village and Avon, OH: Sheffield Village Historical Society and Avon Historical Society, 2010.

Herdendorf, Charles E., James A. Conrad, and Ricki C. Herdendorf. *Historic St. Teresa Cemetery 1853–2009: Historical Analysis and Information Database.* Sheffield Village, OH: Sheffield Village Historical Society, 2009.

Herdendorf, Charles E., and Ricki C. Herdendorf. *Historic Garfield Cemetery 1817–2006: Historical Analysis, Description, Maps, and Information Database.* Sheffield Village, OH: Sheffield Village Historical Society, 2006.

Koff, Lois Ann, and Marian Quinn. *Faith, Joy & Tears: The Klingshirn Saga Continues.* Avon Lake, OH: Westfair Publishers, 1984.

Lake, D. *Atlas of Lorain County, Ohio.* Philadelphia, PA: Titus, Simmons and Titus, 1874.

McQuillin, Steven, ed. *Preserving Our Past: Historic Preservation, Landmark Buildings and Sites in Lorain County and Vermilion, Ohio.* Elyria, OH: Lorain County Regional Planning Commission Report No. 20, 1977.

Quinn, Marian. *Harvest of Memories: Andrew and Emma Conrad.* Avon Lake, OH: Westfair Publishers, 1996.

Smith, James. *An Account of the Remarkable Occurrences in the Life and Travels of Col. James Smith During his Captivity with the Indians in the Years 1755–1759.* Lexington, KY: John Bradford, 1799.

Wright, George Frederick. *A Standard History of Lorain County.* Vols. I and II. Chicago, IL: Lewis Publishing Company: 1916.

ABOUT THE SOCIETY

The Sheffield Village Historical Society has as its mission to discover, collect, archive, and interpret documents, photographs, artifacts, and other materials that establish and illustrate the history of Sheffield and its environs. The society's goals are to advance the appreciation of the village's rich heritage by making historic information available for research and general interest, providing educational opportunities for all age levels, and encouraging the preservation of historic artifacts, monuments, and structures for the benefit of future generations. The Sheffield Village Historical Society, formed in 2005, is an all-volunteer organization with an enthusiastic membership of over 300 individuals and businesses. With a focus on Sheffield's rich heritage, the society strives to engender civic pride in the community for old and new residents alike.

Sheffield Village is a traditional farming community of 4,000 inhabitants in northeastern Lorain County, Ohio. It was settled by New England families in 1815 as part of the Connecticut Western Reserve and was organized as the first township in Lorain County in 1824. Today Sheffield Village is in a period of transition as development spreads westward from metropolitan Cleveland. The society is fortunate to have obtained and renovated an early 1900s farmhouse as its headquarters. Known as the Sheffield History Center, it serves as an office, museum, and archive facility. The society is also fortunate in that many descendants of early settlers still live in the area and have graciously contributed documents, photographs, and artifacts to the history center. One ongoing project is the preservation of these materials and the preparation of digital images of accessioned items.

The society has undertaken a number of projects to fulfill its mission. *The Village Pioneer*, an all-color quarterly journal has been recognized as the outstanding small historical society newsletter in the state by the Ohio Association of Historical Societies and Museums and was conferred an Excellence Award for Public Outreach in 2007. The society has been instrumental in the preparation of building nominations for the National Register of Historic Places and the Ohio Historic Inventory. In conjunction with the Cleveland Museum of Natural History and Lorain County Metro Parks, the society has sponsored archaeological excavations and workshops at several prehistoric sites in Sheffield. Presentations on the research findings of the society are regularly given at educational institutions, libraries, historical societies, and other civic organizations.

www.arcadiapublishing.com

Discover books about the town where you grew up, the cities where your friends and families live, the town where your parents met, or even that retirement spot you've been dreaming about. Our Web site provides history lovers with exclusive deals, advanced notification about new titles, e-mail alerts of author events, and much more.

MADE IN THE

Arcadia Publishing, the leading local history publisher in the United States, is committed to making history accessible and meaningful through publishing books that celebrate and preserve the heritage of America's people and places. Consistent with our mission to preserve history on a local level, this book was printed in South Carolina on American-made paper and manufactured entirely in the United States.

This book carries the accredited Forest Stewardship Council (FSC) label and is printed on 100 percent FSC-certified paper. Products carrying the FSC label are independently certified to assure consumers that they come from forests that are managed to meet the social, economic, and ecological needs of present and future generations.

FSC
Mixed Sources
Product group from well-managed
forests and other controlled sources

Cert no. SW-COC-001530
www.fsc.org
© 1996 Forest Stewardship Council

Find Your Place in History.